The Campus History Series

OLYMPIA
HIGH SCHOOL

ON THE COVER: The 1935 Olympia High School football team poses in front of the Capitol Way School. (Photograph by Vibert Jeffers; courtesy Washington State Archives, Susan Parrish Collection. Also available in the *Olympus*.)

The Campus History Series

OLYMPIA HIGH SCHOOL

JIM KAINBER

ARCADIA
PUBLISHING

Copyright © 2007 by Jim Kainber
ISBN 978-0-7385-4811-1

Published by Arcadia Publishing
Charleston, South Carolina

Printed in the United States of America

Library of Congress Catalog Card Number: 2007927747

For all general information contact Arcadia Publishing at:
Telephone 843-853-2070
Fax 843-853-0044
E-mail sales@arcadiapublishing.com
For customer service and orders:
Toll-Free 1-888-313-2665

Visit us on the Internet at www.arcadiapublishing.com

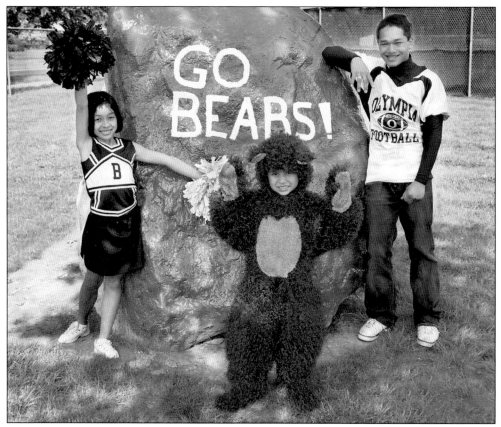

To Paul, Layla, and Ali, who, God willing, will be graduates of the OHS classes of 2009, 2017, and 2020, respectively. Their patience with this project was not always endless, but their interest in this book was always keen. Thank you, guys! I love you! (Courtesy Charlie Kirry.)

CONTENTS

Acknowledgments		6
Introduction		7
Bibliography		8
1.	Places That Brought Students Together	9
2.	Big Personalities and Luminaries	37
3.	Classes, Academics, and Co-Academic Pursuits	63
4.	Fun Times: Dances, Plays, Festivals, and Debauchery	81
5.	The Sporting Life: Athletics and Club Sports	103
Luminaries		126

ACKNOWLEDGMENTS

The only thing that could be more interesting than rummaging through historical files is having professionals in the field of archiving going the distance to push me to find more. My friends at the Washington State Archives in Olympia did just that. This book would have had far fewer fantastic images without the help of Lanny Weaver, Mary Hammer, and OHS graduate Roger Easton. Their love of historical photographs and ephemera is humbling. Elaine Miller of the Washington State Historical Society and Nicolette Bromberg of the University of Washington Special Collections were very helpful in the early stages of research.

So many OHS faculty and alumni were involved in assisting me, but current principal Matt Grant, former principal Dale Herron, and Dean of Students Bill Maguire were especially supportive, as were Kathy Peterson, Marilyn Seely, Bev Frost, and Kathy Thompson. Had it not been for the solid education I received from former teachers Mary Campbell, the late Ron McCabe, and Karline Bird, my skills in writing would have never been strong enough to make this book possible.

Thanks to Arden Darnell, Dana Larson, Cindy Hoehne Dunson, Connie Phegley, and Suzanne Bailey-Giuntoli, my classmates from the OHS class of 1987, for carrying the load of planning our class reunion while I was working on this book.

Thank you to the following people for sharing reminiscences, information, and their personal collections: Jay and Helen Rockey, Mrs. Oliver Ingersoll, Don Ingersoll, Dale Hojem, Deena Harbst Chase, Wendell Carlson, John and Chris Kiley, Bob Ward, Scott Rutledge, Laurie Creighton, Jim and Julie Haase, Jane McKillip, Jackie Carsley, Bette Maguire, Jane Smart Connon, Sue from Harmony Antiques, Valerie Pope Nunn, and Jami Heinricher at The Sherwood Press. Thanks also to *Olympus* editor Rachel Reclam, reporters Craig Cook and Bob Clouse, advisor Carissa Riley, and Jeff Waddington and his Olympia News Network reporters.

Special thanks to my Olympia High School Alumni Association colleagues Hon. Gerry Alexander, Jane Straight Craig, Dick Craig, Elizabeth Dever Halvorsen, Dan Berschauer, Carole Finger Watson, and especially Anna Craig Berry, Winnifred Castle Olsen, and Bill Curtis, each of whom could have written this book as well as or better than I have.

Finally, thanks to my good friend Charlie Kirry, whose enthusiasm for documenting the history of our alma mater is second to none. Of course, none of this would have been possible without the inspiration of my parents, Julie and James Kainber, who were always supportive of me and of OHS, despite having been Aberdeen Bobcats in their earlier years.

INTRODUCTION

Olympia High School has a long history of excellence that dates to the early days of Washington State. When Olympia-Tumwater became the first area in the Oregon Territory (later the Washington Territory) to have a permanent settlement, it quickly grew into a company town, one whose main business was government and whose most important resource was its people. Many of the city's founders were well-educated people from the East, and they brought with them a desire to bring their children up with a public education. The first all-age school was built in 1852 and had only one room. Its doors opened 37 years before Washington became a state.

The founders of Olympia, its early governors, and its business pioneers—individuals with names such as Lemon, Sylvester, Talcott, Woodard, Schmidt, Ruddell, Stevens, and Bigelow—all had a part in shaping its schools. These institutions, including Lincoln School, the Washington School, the Charter Academy, and the Olympia Collegiate Institute, included both public and private endeavors that educated children of all ages.

In 1906, a one-block parcel of land was given by Mary McFadden Miller in memory of her late husband, Gen. William Winlock Miller, and the seeds of a stand-alone high school were planted in Olympia. William Winlock Miller's story is intertwined with the history of Washington and of the entire nation. A decorated Civil War hero, he came to the Washington Territory as its first superintendent of Indian affairs and customs officer. He quickly saw the potential of the region, and he amassed a personal fortune in land all across the Puget Sound region. It is safe to say that one could not travel more than a mile from Interstate 5 between Seattle and Longview today without driving across land once owned by Miller. A list of his friends reads like a map of Seattle streets and University of Washington buildings; among them were founding fathers Denny, Yesler, and Blaine. Some of the places named for Miller and his family are Millersylvania Park, the city of Winlock, Miller Hall at the University of Washington, and, of course, William Winlock Miller High School, more commonly known as Olympia High School.

When William Winlock Miller High School opened its doors as the stand-alone Olympia High School in 1907, it did so in grand style. The school was housed in a beautiful Tudor-style building of stone, by Seattle Schools architect James Stephens, located adjacent to what is now the sunken garden in the shadow of the capitol. Grand plans to expand the capitol and create a Greek classic Capitol Campus required the school to move across Capitol Way to a new site next to the Thurston County Courthouse, which is now used for state offices. But in 1918, before the move could be completed, tragedy befell the school when fire ripped

through the building. Men working nearby rushed into the burning building and managed to save a few books and files before the school collapsed into a pile of smoldering timbers in a stone shell. Classes were held in the Olympia Opera House the following year until the new school was finished. Students moved into a gracious new building in 1919. Olympia High students would call the building home for the next 43 years.

America came of age during the years OHS stood at Capitol Way and Twelfth Avenue. World War I ended, World War II and the Korean War came and went, the Great Earthquake of 1949 shook the Puget Sound region and damaged the state capitol, and the Beatles took the nation's youth by storm. In 1961, over a three-day period, students helped pack the moving vans at the old school and move to the present location, once a dairy farm owned by Gov. Isaac Stevens's son Hazard. The Stevens house still stands just across the street from the northwesternmost corner of the OHS campus, overlooking a small lake to the rear and the school to the front. One can look from the upper-floor windows and see the whole OHS campus. It is not hard to imagine cows grazing in between the barns that once stood where the students now park their cars and eat their lunches.

The year 1961 was significant not only because OHS opened its doors but also because students to the south of the new school in Tumwater were soon sent to the brand-new Tumwater High School. Students from Boston Harbor, the east side, the west side, the brand-new communities that had been build on and around North Street and Carlyon Streets, the South Capitol District, and downtown all still walked, rode their bikes, or rode the bus to Olympia High School.

Throughout this book, I have done my best, given the records available, to accurately record events and images, though, as with any research on the early days of Washington's history, the facts are often based upon recollections and conjecture. Successful book sales may lead to a reprint in the future and an opportunity to right any wrongs that may have occurred in the following pages or to add any information that is missing. Any such information, as well as donations of materials to the school archives, may be left at the front desk of OHS at any time during the school year.

BIBLIOGRAPHY

Blankenship, George. *Old Olympia Landmarks.* Olympia: self-published.
Bowden, Angie Burt. *Early Schools of the Washington Territory.* Seattle: Lowman and Hanford Company, 1935.
Knox, Esther R. *A Diary of the Olympia School District: 1852–1976.* Olympia: self-published. Courtesy of Timberland Regional Library.
Lang, William L. *A Confederacy of Ambition: William Winlock Miller and the Making of Washington Territory.* Seattle: University of Washington Press, 1996.
Olympiad. Olympia High School yearbook.
Olympia's Past Revealed through its Historic Architecture. Olympia: Olympia Community Planning and Development, Advance Planning and Historic Preservation, 2000.
Olympus. Olympia High School newspaper.
Polk City Directory.
School Statistics. State Superintendent of Public Instruction.
The Olympian.

One
PLACES THAT BROUGHT STUDENTS TOGETHER

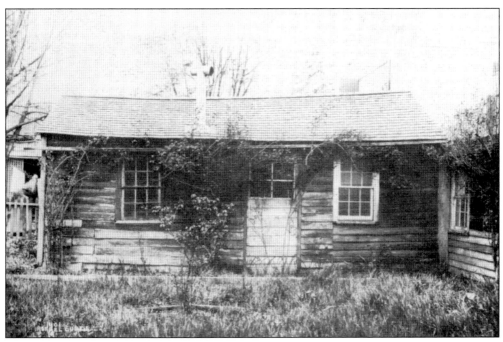

This building is widely documented as Olympia's first schoolhouse. Various accounts put the photograph taken at the beginning of the 20th century, but most agree that the school was used from about 1852 until 1855, when snow compromised the roof. Like many public buildings of the time, it served other needs as well, functioning as a church and as a meeting place for settlers. One early settler, George H. Hime, referred to this Tumwater building in this way: "In the latter part of October 1855, my sister and I were attending a 'rate bill' school taught by Marcus McMillan in the rude log schoolhouse on the extreme northern edge of Chambers Prairie, know as the 'Ruddell Schoolhouse.'" Another account referenced the same building as the Parson's Schoolhouse and discussed the wide prairie and large trees that became the de facto playground for the students. Yet another account put the school at Sixth and Franklin downtown. The school was tuition based; it would be decades before public school districts were funded by taxes. (Courtesy University of Washington.)

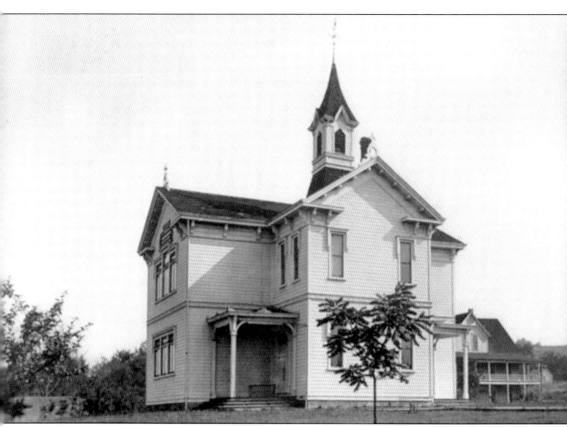

The Olympia Collegiate Institute was a private boarding school that served many of Olympia's early settlers. It was later used by the Peoples University, a predecessor of the University of Puget Sound. According to the *Morning Olympian*, Olympia High School students met here from 1906 until the school at Twelfth and Columbia opened in the spring of 1907. (Courtesy Roger Easton)

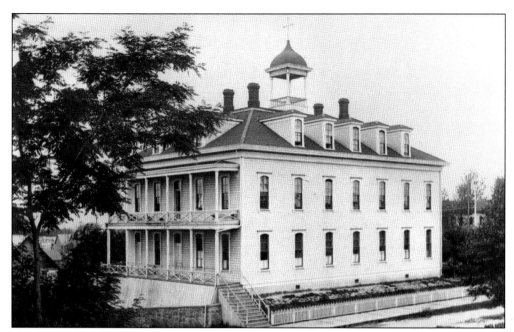

The Sisters of Charity School, shown here in 1882, stood at Ninth and Columbia in downtown Olympia. It was one of the territorial schools that filled the gap when public school funding was unreliable. Its founders have ties to St. Peter Hospital and to St. Michael's Church and school. (Courtesy Thurston Regional Planning Council.)

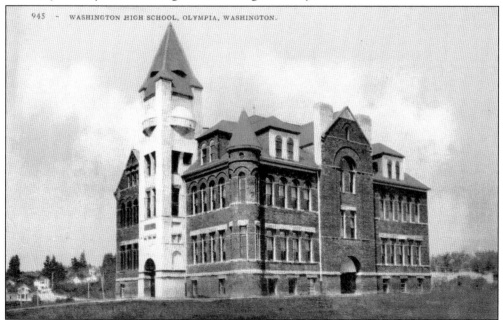

This postcard from the beginning of the 20th century shows the magnificent "Washington High School," which was actually an all-ages school. Early exaggerations such as this were common in postcards to give the impression of a much larger and more prosperous area to the recipients. After the openings of the new Garfield and Roosevelt Schools, Washington became and remains Olympia's first junior high, now middle school. (Author's collection.)

FINE SITE FOR HIGH SCHOOL DONATED FREE

GIFT OF MRS. MARY M. MILLER

Generous Offer Made to School Board Today Located Near Old Capital Building Whole Block Valued at $8,000

FREE SITE FOR HANDSOME STRUCTURE.

Through the generosity of Mrs. Mary M. Miller, the question of the location of the new High school building and the character of the building to be erected has been definitely settled and in a manner that will be highly gratifying. Mrs. Miller has donated to the district the full block of ground located between Water and Columbia and Twelfth and Thirteenth streets. She had valued the property at $8,000.

The only condition attached to the gift is that the building erected shall be of a substantial and permanent character and shall be known as the Miller school in memory of the late William Winlock Miller, husband of Mrs. Miller. They were formerly well-known residents of Olympia.

The school board will sell the site owned by the district on Union street, which is valued at about $4,000, and apply that sum toward the new High school building. While the building material has not been definitely chosen, it will be more substantial than brick, probably of concrete and stone.

Gift Unsolicited.

The gift of Mrs. Miller to the district is more gratifying from the fact that it came entirely unsolicited. Mrs. Miller was asked to name the conditions under which she would sell the block of ground and replied by offering it to the schools free.

The school board will at once make arrangements looking to the erection of the building. This afternoon the members of the board will leave for Seattle where they will make an inspection of the new school buildings of that city, and will consult with architects relative to plans.

Mrs. Miller attended the meeting of the school board today and made the proposition.

The block is just west of the T. M. Reed home on Main street, and a little northeast of the old Capitol grounds. The site is a commanding one overlooking the sound. It is almost level and will require very little grading.

Gave School Site in Seattle.

Mrs. Miller's gift toward the cause of education means much to Olympia and on all sides are heard expressions of gratification. Recently she gave a block of ground for a play ground adjoining one of the Seattle schools.

Mrs. Miller's friends state she expressed disapproval of the publicity given the gift and in the same spirit deprecated the desire of the local newspapers to make more than passing mention of her present gift.

NEW HIGH SCHOOL BUILDING

Will Be Built on Site Donated by Mrs. Miller An Interesting Meeting.

Monday evening at the Superior Court room a meeting of a number of our citizens was held pursuant to the request of the School Board of District No. 1. Byron Millett was chosen as chairman and Fred Schomber was elected Secretary of the meeting.

The chairman remarked it is to be regretted there were so few of our citizens in attendance upon an occasion fraught with so much interest to our community, but he expected the audience to make up in quality what it lacked in quantity, for all is well that ends well.

At the request of the chairman Mr. Schomber stated the object for which the meeting was called, who said it was generally understood the School Board had been offered as a free gift a magnificent site for a high school structure by Mrs. Mary M. Miller, in the southern part of the city known as block 86 in Sylvester plat, provided the district erected a permanent structure of stone or brick on this site, or at least partly of such material; that the district was only expected in the first instance to use the ten mill levy voted on and the proceeds of the sales of the lots on Union street, all of which will amount to about $30,000, the estimated cost being $35,000; that there were other funds available within the 1¼ per cent. limit, which the board might use for this purpose, making the total of $37,000, which may be used in case of an emergency, and the meeting was called for. The purpose of getting an expression from our citizens as to whether the board will be justified in making this additional expenditure of $5,000.

Mr. C. H. Springer moved that it is the sense of the meeting this extra indebtedness be incurred and the structure be built of stone in order to secure this munificent donation from Mrs. Miller. This motion was seconded by Dr. J. W. Mowell. Rev. R. M. Hayes spoke for a few minutes saying he did not attend the meeting expecting to take an active part in its proceeding, as he had incurred considerable adverse criticism regarding his position he had assumed at the last school election with respect to the construction of a high school building; in order to advance the best interest of our community, he believed the board should go ahead and secure the site offered by Mrs. Miller.

Mr. Springer said he considered it advisable to erect a stone structure especially in view of the site including the district which is costly $5,000; he thought there will be grafts or charges for extras to amount to anything above the contract $35,000, as the school district had the matter well in hand, do their best to avoid additional expenditures.

Mr. C. B. Mann made a plea against the proposition; he was in favor of economy of public concern.

The only known original copy of this article was found in the personal scrapbook of Mrs. Miller at the University of Washington. The article details the excitement among the citizenry of Olympia that a suitable site for a stand-alone high school had been donated. (Courtesy *The Olympian*.)

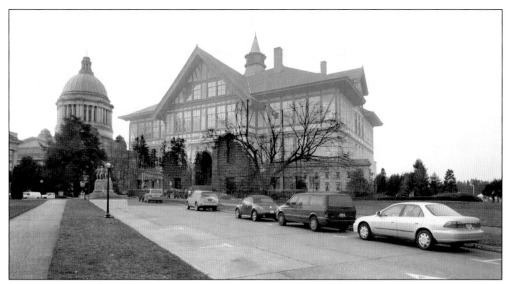

The first William Winlock Miller School is shown here as a ghost lingering where it once stood. The site, originally called Block 86, Sylvester Plat, was located just north of the Wing Victory Circle, only feet to the east of the sunken garden, which would have been in the school's backyard. (Courtesy Charlie Kirry.)

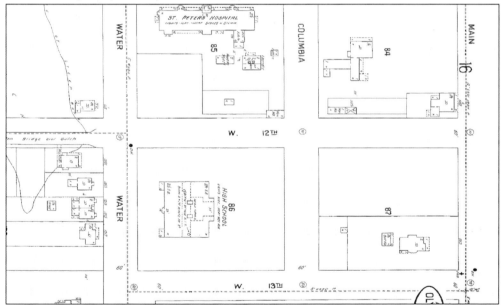

The Sanborn Map Company produced detailed maps of area cities from 1867 until the 1970s. They were meticulously measured and used by planners and insurance companies, providing the most accurate information as to the locations and positions of major buildings. The detail is a bit hazy on this 1909 map, but it gives a clear perspective of the first William Winlock Miller campus at Twelfth and Columbia. Two blocks to the east is Main Street (now Capitol Way). Just to the north is huge St. Peter Hospital, located upon what is currently the north lawn of the capitol, across the street from the General Administration Building. All the streets were erased from the grid when the Capitol Campus master plan was implemented in the 1920s. (Courtesy Washington State Archives.)

13

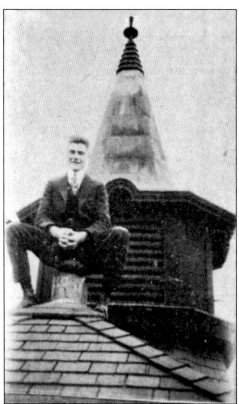

An enterprising student sits atop the peaked roof of the first William Winlock Miller School in 1918. Several accounts of practical jokes and other such hijinks of the times lead one to assume that he was either taking a dare or was the loser a bet. (Courtesy *Olympus.*)

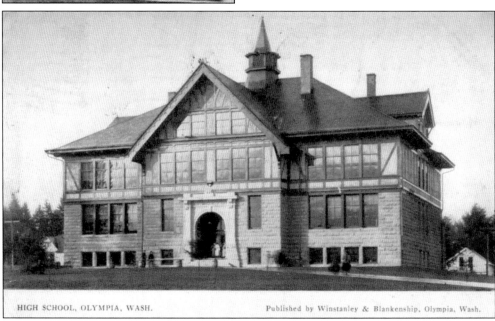

Postcards such as this one captured the significant architectural achievements of the time, and Olympia High School was a major building from the moment it was finished. This image shows the front of the school as it was seen in 1908 or 1909. You can get a sense of its size if you notice the students standing in the front doorway. (Courtesy James Kainber.)

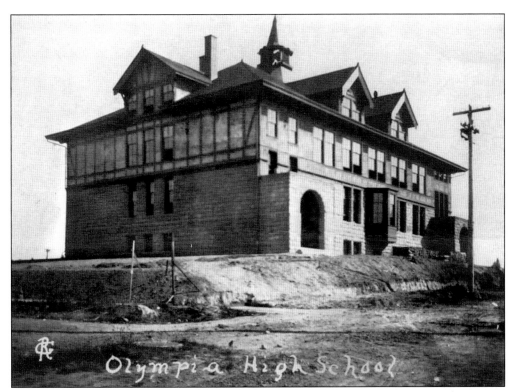

This is a rare rear view of the Twelfth and Columbia school from about where the State Capitol Conservatory stands today. Just to the right of the telephone pole is the site of the current sunken garden. (Courtesy Washington State Archives.)

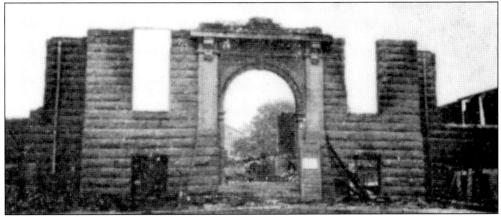

All that remained of the first William Winlock Miller High School after the July 2, 1918, fire was the charred remnants of the three floors above, which collapsed into the basement and were surrounded like a fire pit by the sandstone walls seen in this image. Workmen from a nearby construction project (most likely the Temple of Justice) ran into the school to save a few files and some desks, but the building was considered a complete loss. (Courtesy *Olympus*.)

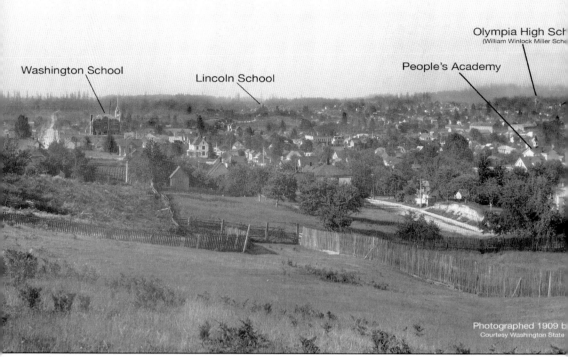

Just two years after the opening of the first William Winlock Miller School, regional historical photography master Asahel Curtis visited Olympia and took this photograph from Olympia's east side, at the same vantage point as the very famous 1879 drawing by E. S. Glover. Clearly visible in the center of the photograph are the State Capitol and the intact clock tower.

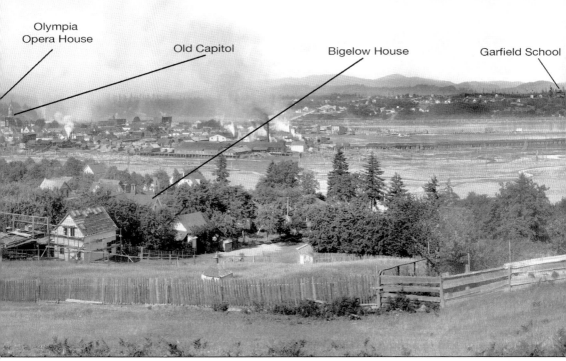

The Washington School, Lincoln School, and Olympia High School can be seen through the trees behind St. Peter Hospital. (Courtesy Washington State Archives, enhanced by Charlie Kirry.)

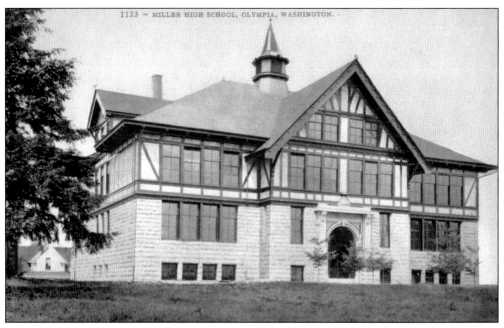

The most readily available image of the first William Winlock Miller School is this hand-tinted postcard from 1910. The Tenino stone along the bottom is either quite blonde or was painted white. The paint across the peak of the building is white with medium-brown timbers, and the roof is a sandy brown color. The house in the background likely belonged to the Rowe family, who had children at OHS. The fate of this house was perilously intertwined with the demise of the school building; embers from the burning school caused the house to catch on fire as well. (Courtesy James M. Kainber.)

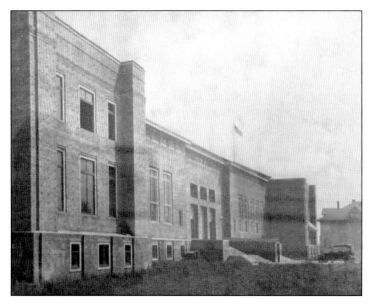

The construction of the Capitol Campus claimed many houses, dozens of vacant lots, St. Peter Hospital, and the first William Winlock Miller School. The Temple of Justice was awaiting its sandstone facade when this image was captured in 1917. Note the hazy outline of Olympia High School, still standing in its final year, in the background. (Courtesy the Washington State Archives.)

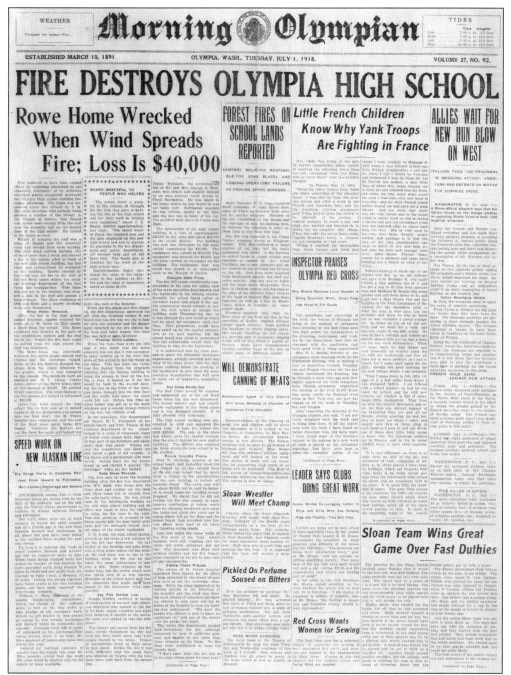

While the headline says it all, the story tells us that almost nothing in this original building survived. It also notes that, although the building had been scheduled to be demolished as part of the Capitol Campus expansion, the alums of the first 11 years of the William Winlock Miller High School were robbed of their chance to say goodbye in proper fashion. The Capitol Way campus was already under construction at the time of the fire, but it was not finished in time for the class of 1919 to begin its senior year there. The students moved in during the school year. (Courtesy James M. Kainber.)

The Olympia Opera House bears mention, not only because it housed OHS from the time the Twelfth and Columbia School burned in 1918 until the Capitol Way campus was completed in the spring of 1919, but also because it was the site of many of the school's early commencement ceremonies. This grand structure, which stood downtown on Fourth between Jefferson and Cherry, was opulently decorated, and it was one of Olympia's first electrified buildings. It succumbed to progress in 1925, as "moving pictures" gained popularity. (Courtesy Washington Historical Society, Tacoma.)

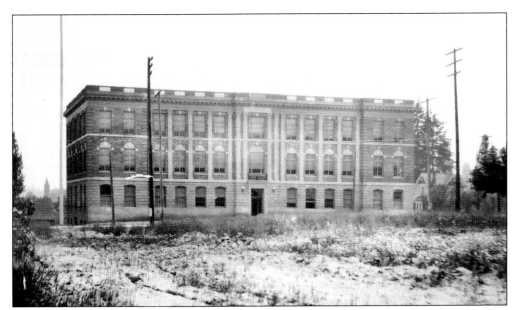

The Capitol Campus, seen here in the foreground, was unfinished as work crews put the finishing touches on the 1918 high school building. Through the haze is the outline of the steeple of the first Lincoln School. (Courtesy Olympia High School Archives. Donated by Winnifred Castle Olsen, '34.)

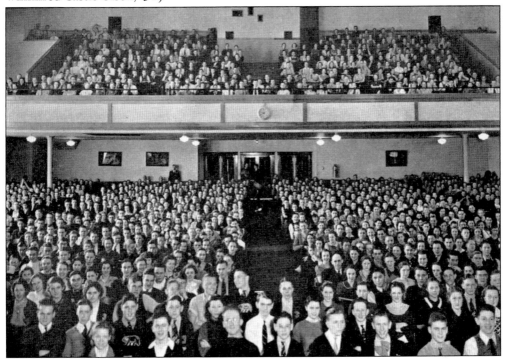

This photograph of the entire student body of Olympia High in 1937 shows the interior of the Capitol Way school's auditorium. When the Cloverfields campus was first built, the theater had seating for only about 100, but a more appropriate performing arts center was added when the campus was remodeled in 2000. (Courtesy *Olympus*.)

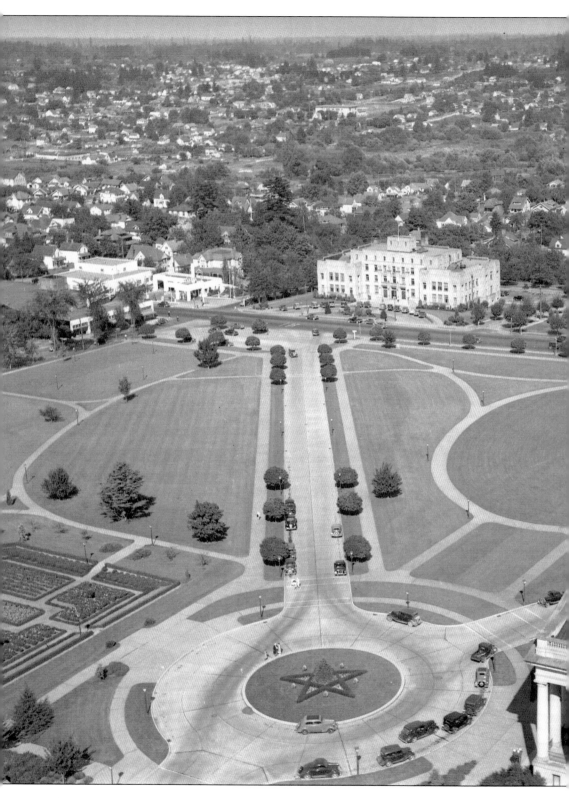

This photograph, taken from the top of the legislative building, shows the lawn of the campus before the Tivoli fountain was donated by the Schmidt family. It also shows the Olympia High School building on Capitol Way, nestled between the old Thurston County Courthouse on the left and the Capitol Apartments on the right. Gone are entire blocks of homes that once stood where the state office buildings are now located. Today Interstate 5 would cut across the upper right corner of this view. (Courtesy Washington State Archives.)

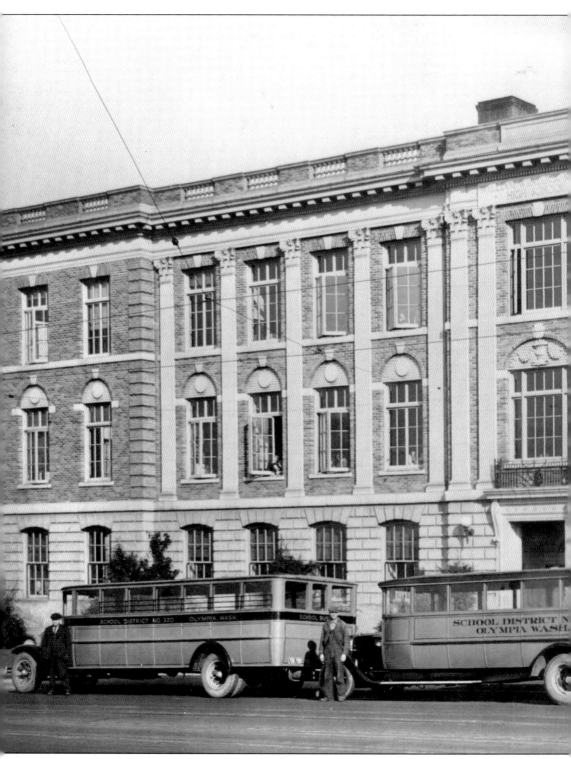

One of the most popular images of the Capitol Way building, this undated view is more interesting for its depiction of student transportation at the time than for the building in

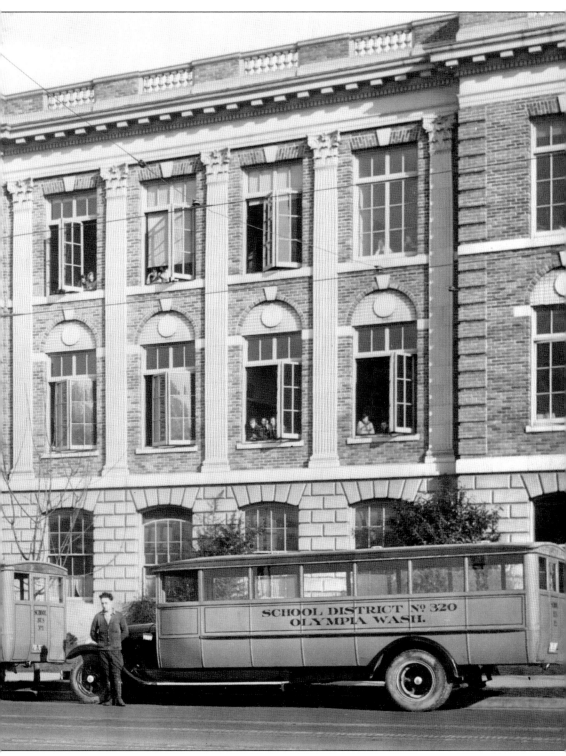
the background. (Courtesy Olympia High School Archives.)

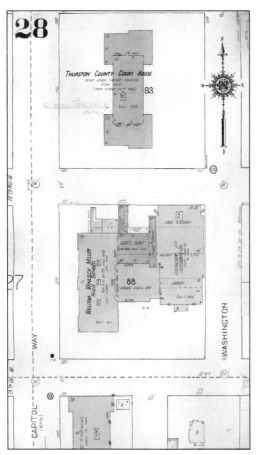

This map shows the position of the second high school building next to the old Thurston County Courthouse building, which remains in the same location. It also reveals an interesting glimpse of the floor plan of the school. The Sanborn Map Company made detailed drawings such as one this by hand. When new buildings such as this one were added, the map makers pasted them into previous editions rather than redoing the entire map. (Courtesy Washington State Archives.)

This is an interior view of the halls of the school shortly before it met with the wrecking crew. (Courtesy *Olympiad*.)

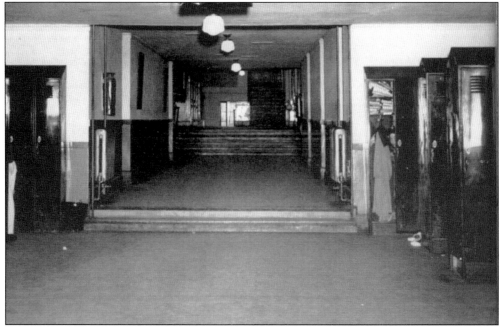

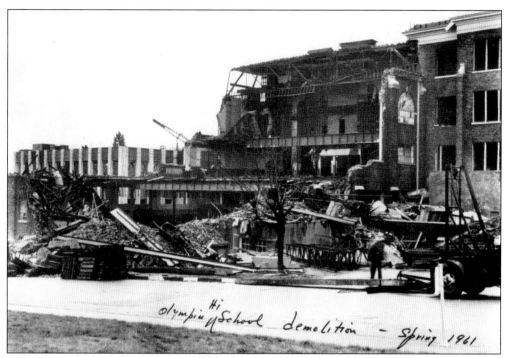

Progress again claimed an Olympia High School building in 1961. Here the demolition teams begin tearing down the building at Twelfth and Capitol. (Courtesy of Washington State Historical Society, Tacoma.)

Only two things remain from the Capitol Way building: a few display cases donated by the class of 1930 and the terra cotta William Winlock Miller High School sign that was above the door. The display cases are now located in the foyer of the gymnasium at Capitol High. The sign was surrounded by bricks from the school and placed by the Carlyon Street entrance to the current school. (Courtesy Charlie Kirry.)

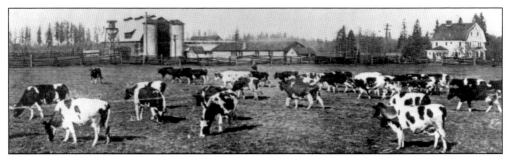

Cows grazing on campus may for some evoke fond memories of Pullman, but, as late at the 1950s, this was the view one would see while driving from Capitol Way to Cloverfields. The Hazard Stevens home can be seen here. Everything to the west of the barns is a neighborhood. To the east of the barns are Olympia High School, Pioneer Elementary School, and Ingersoll Stadium. (Courtesy Thurston Regional Planning Council.)

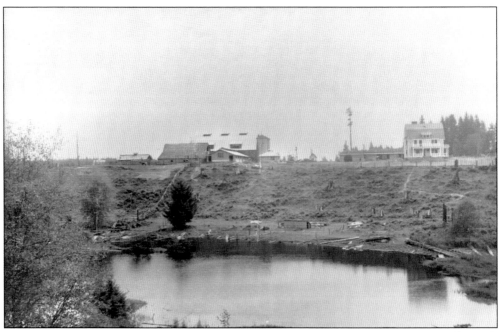

This late-19th-century view across Hazard Lake shows the Hazard Stevens home. It still stands on the only bend on Carlyon Avenue. The barns, which were located on what is now the OHS student parking lot, can be seen in the background. The land on which the house, the entire OHS campus, and most of the adjacent neighborhoods are situated was once part of the Cloverfields Farms Dairy. (Courtesy Thurston Regional Planning Council.)

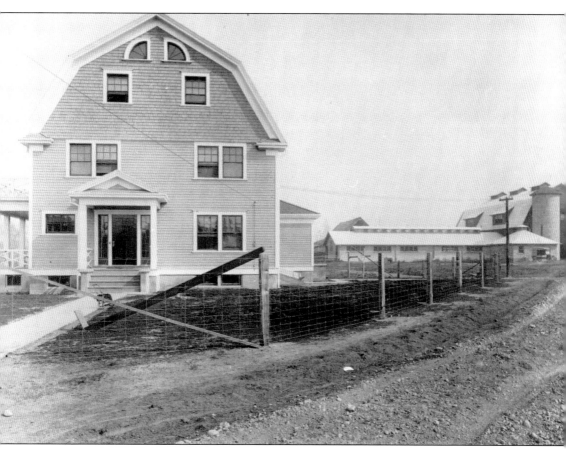
This view of Cloverfields shows the barn in the background and the imposing structure of the Stevens home in the foreground. (Courtesy Thurston Regional Planning Council.)

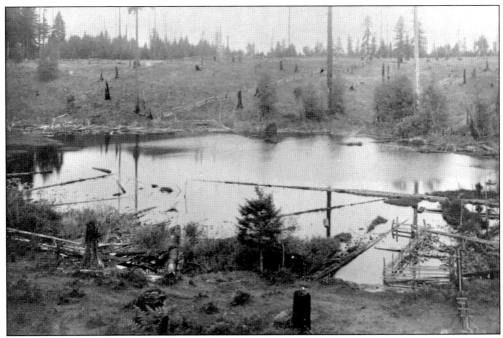

This is a view of the surrounding neighborhood from Cloverfields, looking north to what is now the Eskridge Street neighborhood. (Courtesy Thurston Regional Planning Council.)

The Cloverfields Building, which featured an automotive shop, housed OHS's vocational education program in the late 1950s. At that time, the campus was still largely a field, and school buses were stored in the large barns that remained from the dairy farm. It is assumed that the term "bus barn" began during this time. Though the buses are no longer housed indoors, their nighttime resting place is still called the "bus barn." This building was the hub of industrial and technical education at OHS until it was torn down when the campus was remodeled in 2000. The site is currently occupied by the theater and the east end of the student parking lot. (Courtesy *Olympus*.)

During the construction of the North Street campus in 1960, it looked as though the office and Hall One were waterfront property. Fortunately, the construction workers filled in this depression before the faculty began using "Lake OHS" for parking. (Courtesy Olympia High School Archives.)

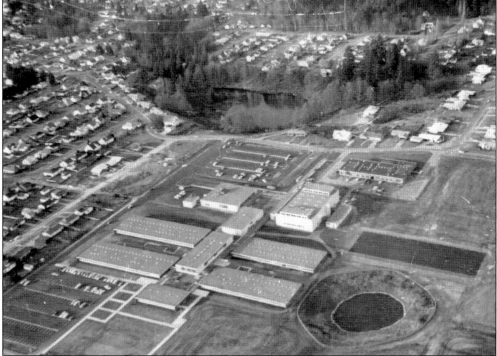

This aerial photograph, taken in 1962, evokes the pastoral history of the school. Carlyon Street looks almost like a gravel road. The layout of the school is much the same today, but gone are the courtyard between the gymnasium and the cafeteria, as well as the open-air walkways that went from building to building. To the right of the gym are the visiting team locker rooms, which many thought were nicer than those of the fighting Bears. The only major difference in the footprint of the school today is that the Cloverfields Building (upper right) was demolished during the remodeling in 2000 to make room for the performing arts center and for more student parking. (Courtesy Washington State Archives, Susan Parrish Collection.)

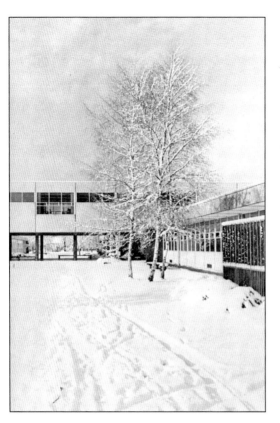

Snow closed the school in 1971, but it did not keep an enterprising *Olympiad* photographer from capturing this image. While all of the elements of the school shown here remain, they were enclosed and rearranged when the school was remodeled in 2000. Hall Four is to the left, and Hall Two is to the right. In the center upstairs was the library, featuring four classrooms in each corner but no elevator. The open area under the library had tile walls of multiple shades of blue. It was called the "Hello Walk" because it was a natural crossroads for students passing between classes, and they would greet one another as they went by. The Hello Walk had been a tradition at the Capitol Way campus as well, and new students who made the move to the new school placed a plaque in the center of the new one to commemorate it. (Courtesy *Olympiad*.)

This image, taken from the dedication pamphlet that was handed out when the North Street school opened in 1962, shows the layout of the campus. While the footprint of the school is the same today, much of the space has been rearranged, and the upstairs library has moved to the main floor of the school, which is now enclosed. Many believed that the original floor plan was taken from designs for schools in southern California, where the climate is much more conducive to an open-air plan. (Courtesy Olympia High School Archives.)

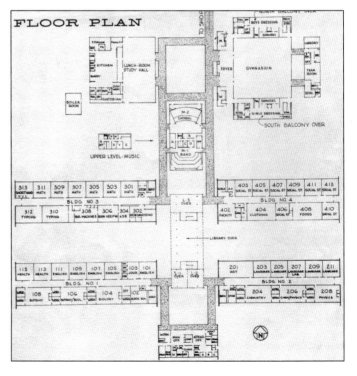

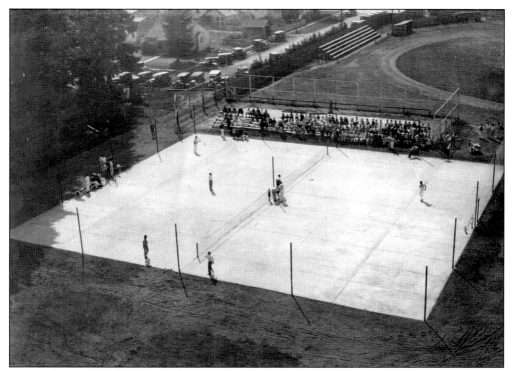

In contemporary times, any McMansion can be thrown up on a quarter-acre lot, complete with its own tennis court. But in 1925, the students of OHS raised money through sales of May Fete tickets to build the school courts, which are still in use at Stevens Field. In this 1931 image, the rooter section cheers the Bears to what was surely another victory. (Courtesy Olympia High School Archives.)

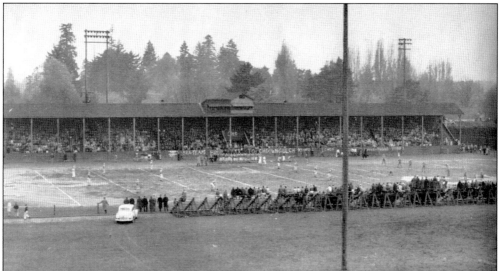

This is another irresistible image of Stevens Field, showing a packed house in 1945. While the tree-lined streets of the South Capitol neighborhood remain highly desirable real estate, few who have located there in recent years have any idea that such a magnificent history was played out on their local playground and soccer field. (Courtesy *Olympus*.)

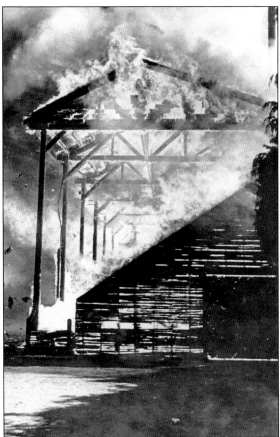

This dramatic photograph shows the profile of the Stevens Field grandstand in the final minutes before it collapsed in 1967. The fire was started by high school smokers, who were reportedly unable to attend school in Olympia thereafter and had to be bussed to private schools in Tacoma. (Courtesy Frank Spickelmeyer and the Olympia Fire Department.)

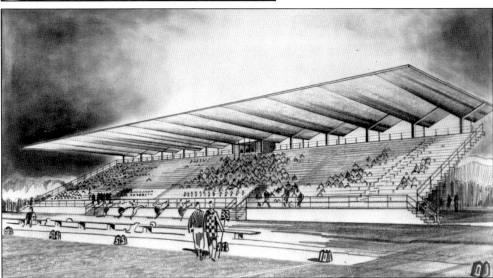

This image shows Ingersoll Stadium as it was envisioned by the architect in the late 1950s. The stadium looks very much like this today, and it remains the center of activity for the many students who participate in football, soccer, and track. (Courtesy Washington State Archive, Susan Parrish Collection.)

Two

BIG PERSONALITIES AND LUMINARIES

Gen. William Winlock Miller, the namesake of the institution better known as Olympia High School, was born in Greensburg, Kentucky, on January 12, 1822. He lived in Missouri and Illinois before moving to the Washington Territory and accepting the position of surveyor of customs from Pres. Millard Fillmore. A close friend and confidante of territorial governor Isaac Stephens, he served as quartermaster general during the Indian Wars, and he was credited with organizing a massive campaign that brought the conflicts to a speedy end. President Buchanan appointed him superintendent of Indian affairs for the territory at about the same time that the people of Olympia elected him mayor, a position he held for two terms. Miller served briefly in the territorial legislature. He married Mary McFadden Miller in 1869, and the couple had two sons. A shrewd businessman, Miller saw great value in leveraging his resources to buy huge tracts of land from struggling settlers. At the time of his death in Olympia on January 24, 1876, he was a very wealthy man with a young family. (Courtesy University of Washington Special Collections.)

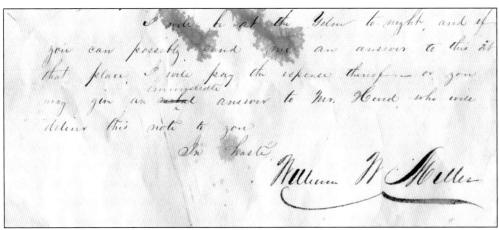

William W. Miller's signature, taken from professional correspondence found in the Miller family papers at the University of Washington, looks almost like calligraphy. In Miller's time, signatures were always done with fountain pens, and the intricacies of the thick and thin lines the pens produced were thought to be integral to the nature of the signature. With the advent of the ballpoint pen, many argued that signatures in ballpoint would not be acceptable for official documents because they lacked the nuances created by fountain pens. (Courtesy University of Washington Special Collections.)

Mary McFadden Miller was almost as important to the history of Olympia High School as her husband William. The daughter of O. B. McFadden, who had served on the Territorial Supreme Court and lived in Seattle and Chehalis, Mary carried on her husband's business affairs from the time of his sudden death in 1876 until her own death in 1927. She also raised their two sons, Pendelton and Winlock, largely by herself. When Pendelton died in his 20s, Winlock became Mary's sole business associate. The Miller family left a legacy in the region: Millersylvania Park is named for them, as are the town of Winlock, Miller Hall at the University of Washington, and, of course, William Winlock Miller High School. Mary Miller donated the land for the school in 1906 on the conditions that the school district name it for her late husband and that the building be made of stone and brick. The lot, then referred to as Block 86, Sylvester Plat, was the ideal location for the new school, and the district and county commissioners accepted her terms gladly. (Courtesy University of Washington Special Collections.)

As final resting places go, William Winlock Miller, Mary McFadden Miller, and their son Pendelton have one of the grandest, located in the Masonic part of the cemetery off Cleveland Way in Tumwater. Most students of Olympia High drive past this spot dozens of times a month, though they have no idea that the remains of important founding fathers of the city and the namesake of their school are there. (Courtesy Charlie Kirry.)

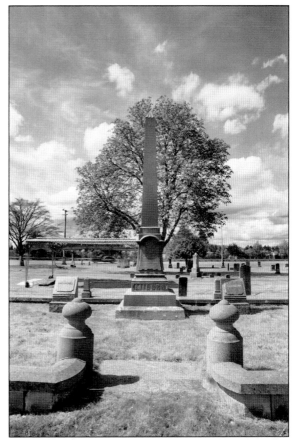

These members of the class of 1902 are, from left to right, Hallie Pierce, Bert Umpleby, Alice Yantis, and Harold Agnew. They attended OHS classes at the Washington School on the east side, where the Olympia armory is today. (Courtesy *Olympus*.)

Gov. Isaac Stevens was born in Massachusetts and graduated from the U.S. Military Academy at West Point. He began an impressive career in the U.S. Army, defending the nation in the Mexican-American War, where he was severely wounded in the Battle for Mexico City. Stevens was a strong supporter of Franklin Pierce's candidacy for president, and he was handsomely rewarded for his support, being named the first governor of the Washington Territory in 1852. Stevens served as governor for several years, and he distinguished himself as a champion of white settlers and an antagonist of Native Americans. A low point in his relations with the native tribes was the execution of Chief Leschi of the Nisqually tribe. While many of the territory's elite were uncomfortable with his leadership, he was elected as the territorial representative to Congress in 1857. Just four years later, he recommissioned in the army to fight in the Civil War. He saw combat in many important battles, including the Second Battle of Bull Run and the Battle of Chantilly, where he was killed. His son Hazard was also wounded in the same campaign. (Courtesy Washington State Archives.)

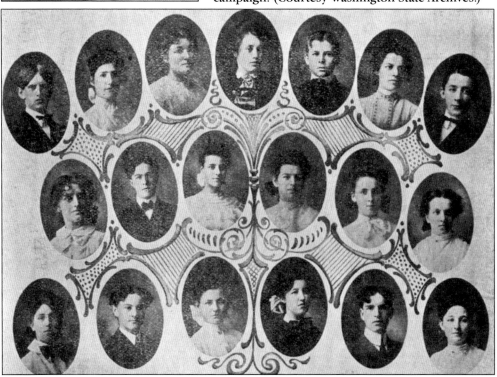

The class of 1905 had no idea they would be one of the last to be crammed into the Washington School, but this beautifully hand-detailed card is an interesting remnant from the pre–William Winlock Miller High days. (Courtesy *Olympus*.)

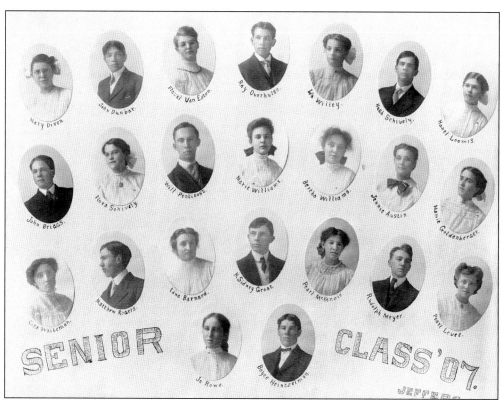

The class of 1907 was the first to attend classes in the William Winlock Miller School, if only for a few months before graduation. These photographs, organized and hand labeled by Joseph Jeffers, Olympia's most storied photographer, were most likely hung on the walls of the school. This image was found by happenstance in the Olympia School District offices. John Briggs (center left) was the first of a long line in his family to attend OHS. (Courtesy Olympia High School Archives.)

Little is known about N. Jessie Aiken, the second principal to serve at the Twelfth and Columbia school. Given that there are no surviving photographs of many of Olympia's founding fathers, it is fortunate that the *Olympus* offered labeled pictures of the faculty in 1918. (Courtesy *Olympus*.)

The faculty of 1913 reads like a who's who of Olympia society. Pictured here are the following: (first row) Ella Jones, Ethel Coulter, Florence Dudley, Jessie Pelton, Margaret Bigelow, Frances Sylvester, and Hannah Phelps; (second row) P. F. Colbert, B. F. Gabriel, Superintendent C. E. Beach, E. R. Thomas, Principal Jesse Aiken, E. R. Loomis, and past principal R. B. McClelland. It is unclear when McClelland was the school's principal and when he was just a teacher, as the responsibilities often overlapped during this period, but he was a fixture at the school for many of its early years. (Courtesy *Olympus*.)

This 1910 photograph of the OHS faculty is the only one available of Principal Staeger (center row, second man from the left). (Courtesy *Olympus*.)

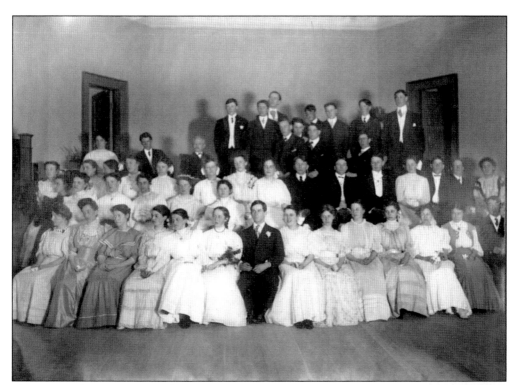

This image shows the class of 1907 and the class of 1908. The latter were the first students to spend an entire school year in the new William Winlock Miller School. (Courtesy Olympia High School Archives.)

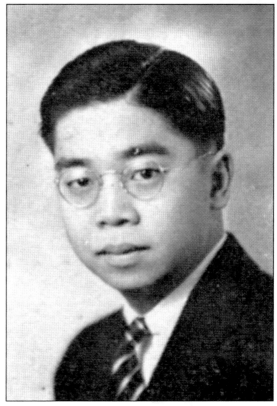

Americans have often had a negative attitude toward immigrants. Olympia in the 1930s was no exception. Gem Locke's father was an immigrant who worked as a servant in the home of a wealthy Olympia family. According to his 1936 classmate, Dale Hojem, Gem "left Olympia and never looked back" after some racial tensions broke out. Locke moved to Seattle briefly before joining the U.S. Army and serving in World War II. He later met his wife in Hong Kong, and they settled in Seattle to raise their family. His son Gary Locke became the first Chinese-American governor in U.S. history, serving Washington State from 1996 to 2004. (Courtesy *Olympus*.)

Leland P. Brown served as principal from 1919 until 1932. He is remembered to this day as the namesake of L. P. Brown elementary school.

Principal Willard J. Matters is seen here in the office of the Capitol Way building in 1949, helping the office staff check in students. He looks very serious in this image, as he did in most portraits. Matters was known to have a level head and a fair hand in dealing with discipline problems, which were few and far between at Olympia High School. He held the position from 1932 to 1954, making him the school's longest-serving principal to date. After his service at OHS, he went on to serve the entire school district as superintendent before he retired. (Courtesy *Olympiad*.)

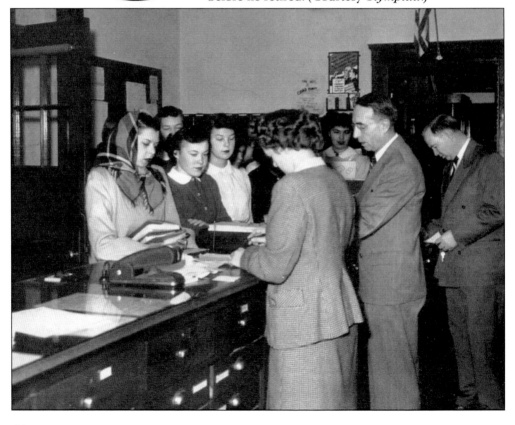

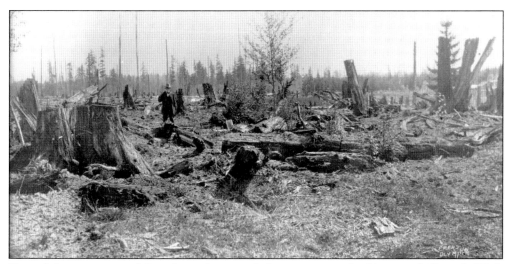

Hazard Stevens, son of Gov. Isaac Stevens, is important to the history of Olympia High School because it was his estate that eventually became the site of the North Street campus. Hazard Stevens was wounded in the Battle of Chantilly in the Civil War, the same battle that claimed his father's life. Here Hazard surveys the clear-cutting of land for his Cloverfields dairy farm, which was a state-of-the-art production farm for the period. (Courtesy Thurston Regional Planning Council.)

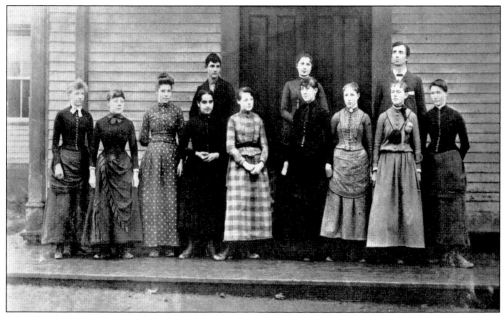

This group has been documented as the graduating class of 1888, but more likely it is Superintendent B. W. Brintnall and his staff in 1887, as others have listed it. Either way, it is an interesting historical artifact from Olympia's early school days. (Courtesy *Olympiad*.)

Chick Rockey, a native of Bellingham, coached at Hoquiam for a couple of years before landing at Olympia High School in 1924, beginning a nearly 40-year career as a teacher, coach, athletic director, and mentor. A wonderful anecdote told by Rockey's granddaughter Susan provides an inside look at the homecoming event at which the school's gymnasium was named for him: "At the assembly, it was very exciting, because Grandpa got to pick the Homecoming Queen. He picked a very pretty blond girl. I then rode back with Grandma Celia to their house in her aqua and white two-toned Chevy. She was so mad at him for not picking the girl she wanted to be Homecoming Queen . . . who was a more 'serious looking' young girl." (Courtesy *Olympiad*.)

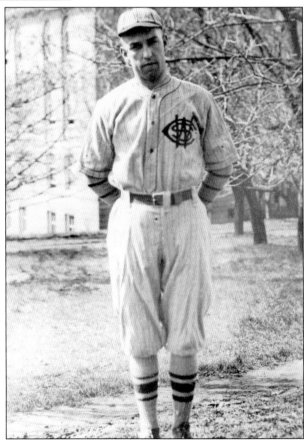

Chick Rockey is pictured here as a baseball player for Washington State College, looking very much the same as he did decades later as the coach of various sports at OHS. (Courtesy Helen Rockey.)

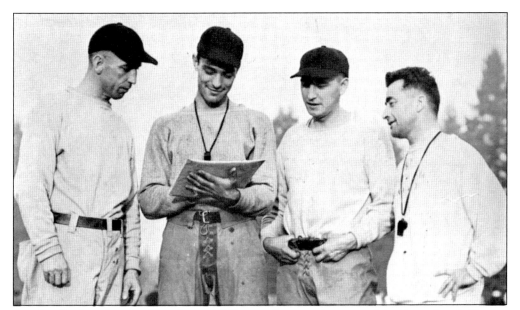

Coaches Rockey, Sander, Koenig, and Miller confer over the state of the Bears baseball team in 1935. (Courtesy *Olympus*.)

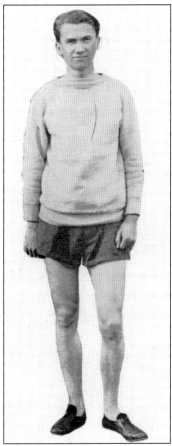

In the 1923–1924 academic year, Olympia High School organized its first school-wide student governance under the leadership of Smith Troy. Troy went on to have a distinguished career in law, serving as Thurston County prosecutor before he was appointed to fill out the term of Garrison Hamilton as Washington State attorney general in 1940. A Democrat, he was retained by the voters of 1944 and was reelected in 1948. Like his generations of successors, Troy was involved in more than student government. He was also a member of several clubs, was captain of the track team, and was honored as a member of the Big O Club. (Courtesy *Olympus*.)

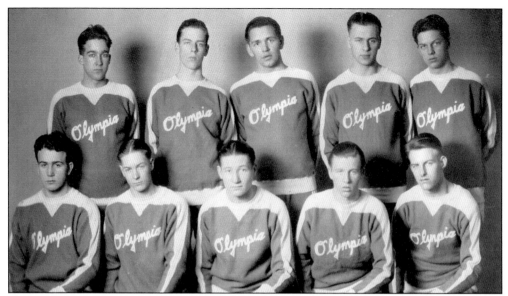

In over 100 years of history at OHS, there have been only two state champion boys basketball teams. One was the 1929 team, led by Coach Chick Rockey, who was in the fourth year of his more than 35-year career. (Courtesy Olympia High School Archives.)

ASB presidents from Olympia High School often pursue successful careers in their chosen fields. One outstanding example is Gerry Alexander (center), who served as ASB president in the 1953–1954 school year. Alexander got his undergraduate and law degrees from the University of Washington, and he served in the U.S. Army before settling into a career in law that led him to the state supreme court, where he served as chief justice. First elected to the high court in 1994, he was reelected in 2000 and again in 2006, his final term before retirement. Justice Alexander, a very loyal alum, also served on the Olympia High School Alumni Association's board of directors. (Courtesy Olympia High School Archives.)

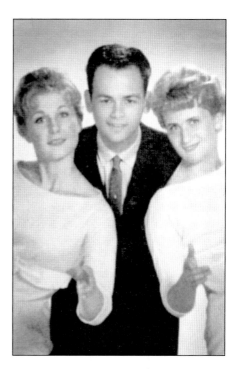

The Fleetwoods received gold records for their million-record sales (a figure that would earn a platinum record today) during their appearance on Dick Clark's *American Bandstand*. The three met while they were students in Olympia, and they formed their vocal trio at Olympia High School. Gretchen Christopher, Barbara Ellis, and Gary Troxel performed Gretchen's a cappella song "Come Softly" at their OHS Senior Class Talent Assembly and at one teen dance before they cowrote an expanded version and gained nationwide fame when the song, renamed "Come Softly To Me," became their first hit album single in 1959. "Graduation's Here" was co-written by Christopher and Ellis for their OHS graduation party and became a top 40 hit in 1959. It was followed by their second number-one hit album single, "Mr. Blue," later that year. The Fleetwoods were the first group ever to have two album singles ranked number one in sales in a single year on *Billboard Magazine*'s rankings, the Billboard Hot 100. (Courtesy Olympia High School Archives.)

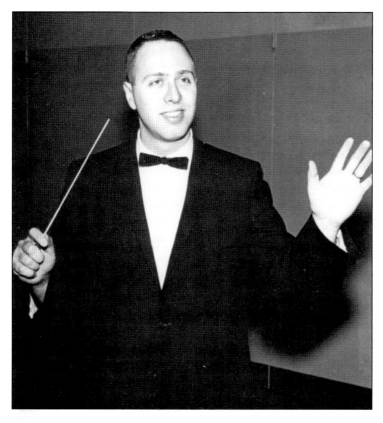

Wayne Timmerman, seen here looking very much the part of hipster maestro, oversaw the band program at Olympia High for decades. "Mr. T," as he was known, took over a program that was made strong under Leslie Armstrong and made it even stronger. He and wife, Karla, were known as the "Ts," and made the OHS music program operate very much like a big family. (Courtesy *Olympiad*.)

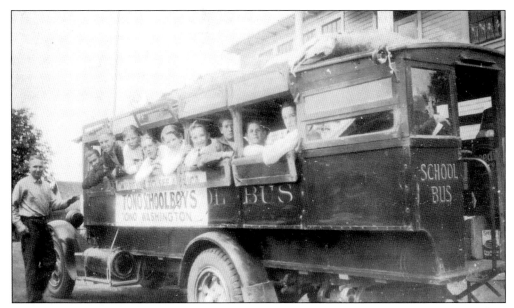

Oliver Ingersoll was a teacher and principal in the Tono School District in the 1920s before he settled in Olympia. Here we see him with a bus full of children, getting ready for a trip either to Canada or to California. (Courtesy Ingersoll Family.)

Ingersoll served as special prosecutor for Mason County in 1936 and for Thurston County in 1940. He was also an Olympia police judge for 10 years. He served 23 years on the Olympia School Board, and, after his retirement, the board honored him by naming the new sports stadium at Olympia High School after him in 1967. Ingersoll's three children attended Olympia High. (Courtesy Ingersoll Family.)

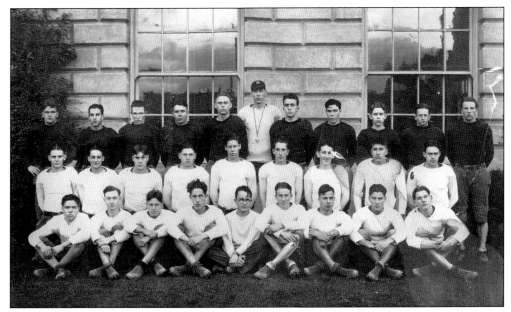

The 1929 football team, under the watchful eye of Chick Rockey, earned the Bears' first state title. (Courtesy Olympia High School Archives.)

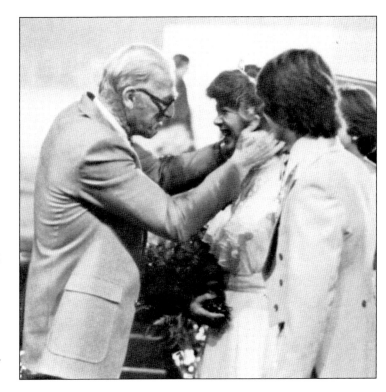

Leslie Metzger served as principal from 1972 to 1982. Here he congratulates homecoming queen Sue Kerr in 1982, shortly before his retirement. (Courtesy *The Olympiad*.)

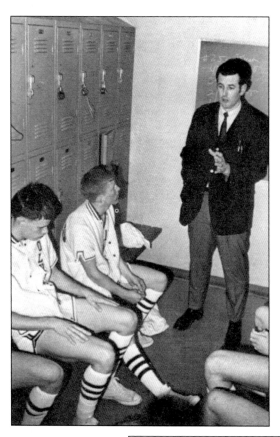

Dale Herron started at Olympia High as a teacher and coach and quickly rose to prominence as a vice principal and then principal of the school. Seen here during his coaching days in 1970, he was always a strong supporter of OHS athletics and academics. Herron's adopted team was the Bears, but he was a graduate of one of Olympia's rivals, Hoquiam High School. (Courtesy *Olympiad*.)

The OHS Bear has gone through a number of incarnations over the 80 or so years that it has been the school mascot. This version designed around 1975 by Bob Strecker has been used, except for a two-year period in the 1980s, ever since as the official bear. (Courtesy Olympia High School.)

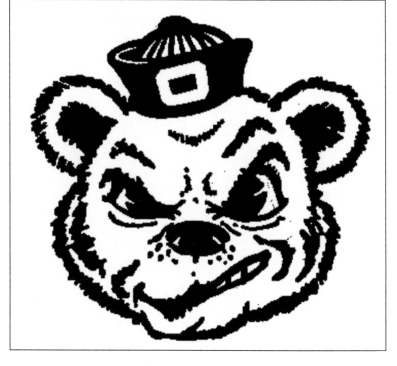

Eric Alexander graduated in 1986 and has made a name for himself in the international world of jazz, revered as one of the best saxophonists in the world. He is one of the most prolific jazz performers of his time, having released over 16 albums under his own name and contributed to many others. E. A., as he was known at OHS, is shown here in 1983, taking a break from the rigors of the Olympia High School marching band. (Courtesy *Olympiad*.)

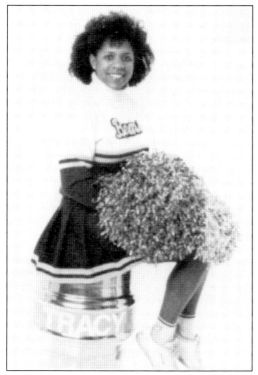

Tracy Overby was the third female ASB president, but she was both the first female cheerleader and the first African American to hold the position. She tipped the balance of power in the ASB presidency, succeeding a line of five football players, a group that makes up the largest number of ASB presidents in the school's history. Overby is shown here proudly perched atop her keg. She and the author were voted the two most spirited members of the class of 1987. (Courtesy *Olympiad*.)

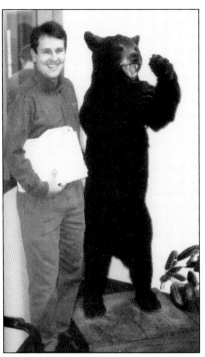

Matt Grant taught in Olympia schools for five years before accepting the OHS assistant principal position, in which he served for three years before becoming principal. He probably had no idea when he was a student at Harvard that later in life he would be communing with wild animals as part of his career as a school administrator. (Courtesy *Olympiad*.)

Dick Allen, shown here overseeing the renovation of the Carlyon–North Street campus, served the school as a guidance counselor and vice principal before taking the reins as principal from Dale Herron in 1995. (Courtesy *Olympiad*.)

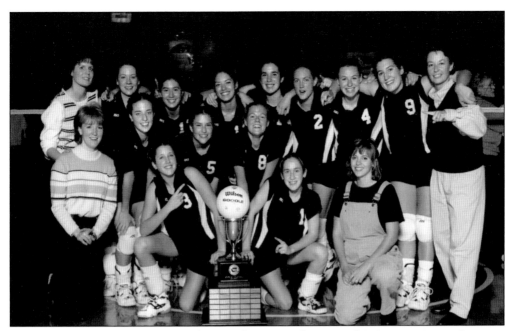

The 1998 volleyball team captured OHS's first state championship in a women-only sport. Coached by Laurie Creighton and assisted by Shelly Cooper-Wilson and Jennifer Ditter, the girls defeated Selah in the finals, held at St. Martin's College. (Courtesy Laurie Creighton.)

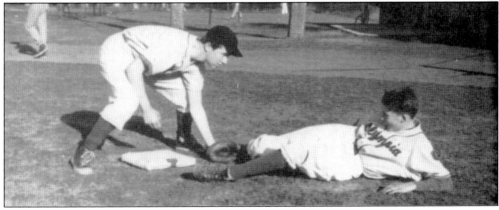

The current baseball field on the Carlyon–North Street campus is Crandall Field, named for Bruce Crandall. This is the only feature of Olympia High School that was named for someone who attended the school. In 2007, Crandall was honored with the Congressional Medal of Honor for his service in Vietnam. While at OHS, he was a star baseball player and made the All-Washington Team. Crandall is shown here in 1951 tagging out fellow teammate Perry Westmoreland. (Courtesy *Olympiad*.)

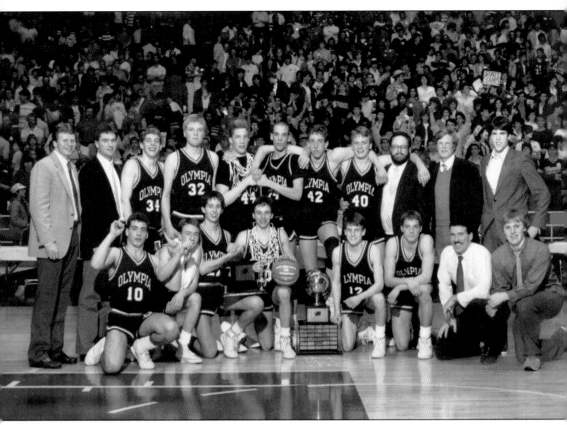

Winning a state championship of any sort is a major boost to the school, but with only two championship basketball teams in the history of the school, the win by the 1986 boys team was a very big deal. Coach Al Sokaitis (first row, second from the right) and assistant coach Bill Curtis (top row, second from the right), who played for OHS from 1959 to 1961, and future head coach Tim Healy (left of Curtis) led the Bears to Key Arena in Seattle, where they won it all. Future Bears coach John Kiley (holding the ball in front) led teams that placed second and third in state competitions in the 1990s, but they fell short of a state title. (Courtesy John Kiley.)

The "'84 War," as it was dubbed by Coach Bob Dunn, was the last statewide victory for Bears football, but Olympia High has always had a strong football program. The mighty Bears won the King Bowl in the King Dome six years before it became the largest in our state's history to be imploded. Shown here is a commemorative button that was sold to fans after the big win. (Author's collection.)

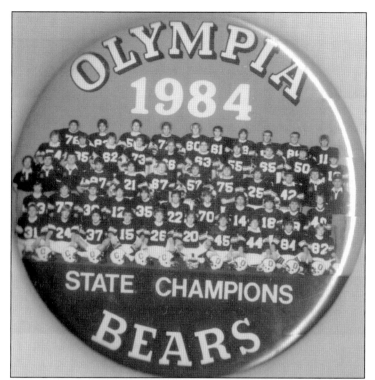

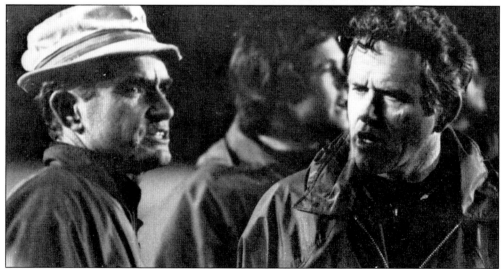

In 1984, Coach Bob Dunn led the Bears to their third state football championship in the program's history. He was not only a skilled coach but also a masterful orator. At the mandatory pep assemblies held before each game, Dunn would detail the team's strategy for victory to the hushed audience. His speeches were always clever, and the crowd listened closely, because at any time the coach could ask "Are you ready?" The students would give a response of a single clap in unison. If the coach was not pleased with the precision of the clapping, he might ask his trademark question several times in a row until he was satisfied. Dunn is shown here earlier in his career with assistants Wayne Sortun and Mike Mulligan. (Courtesy *Olympiad*.)

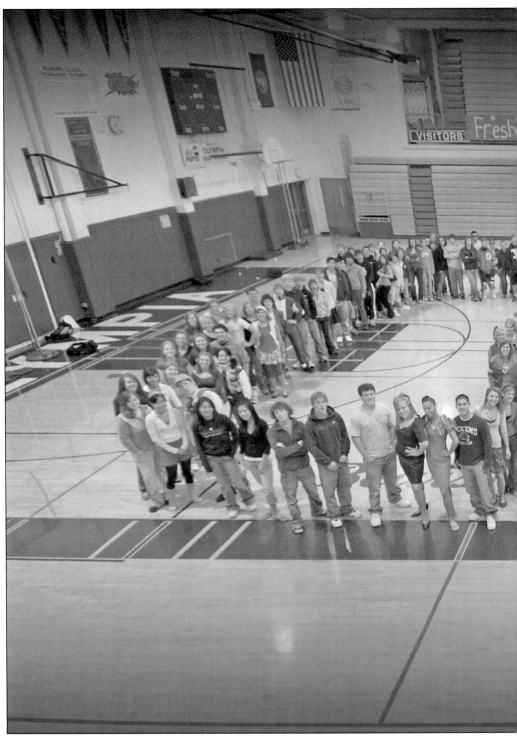

The class of 2007, numbering 431 students, graduated on Monday, June 18, 2007, at the St. Martin's University Pavilion. The class is shown here in a traditional pose, forming their graduation date in the newly remodeled Chick Rockey Gymnasium. The author attended

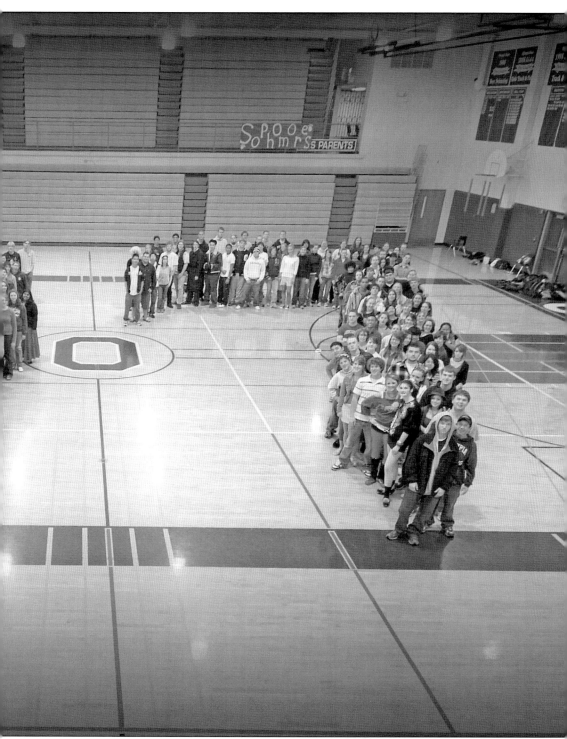

the event to see his brother Reid Kainber become the family's second graduate of OHS. (Courtesy Fitzgerald Photography.)

Olympia High School

Monday Evening
June 18th, 2007
7:00 P.M.

Saint Martin's
Pavilion

Graduation Ceremony 0193

In the early days of Olympia, high school commencements were community-wide events. Today the classes are so large that tickets must be issued. The class of 2007 received only seven tickets per student, but crafty parents with larger families were able purchase tickets from scalpers at around $10 each. (Author's collection.)

Olympia High School

Commencement Exercises
of the

Class of 2007

Monday
June 18, 2007
7:00 p.m.
St. Martin's Pavilion

This is the commencement program from June 18, 2007, the day that the 100th class graduated from the William Winlock Miller School. It features the updated, stylized version of Dudley Dohm's seal, which was designed for the school's 20th anniversary. (Author's collection.)

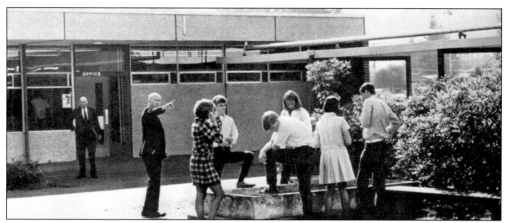

Don Bunt served as principal from 1954 to 1972. He is seen here shooing students from playing in the senior fountain at the original Carlyon–North Street campus. The fountain was long gone by the 1980s. When the school was remodeled, this area became the hallway that leads from the office to the rest of the school. Bunt saw the school through the move from Capitol Way to the present location as well as through some major historical events, including the Vietnam War and the shifting of social standards in the 1960s and 1970s. (Courtesy *Olympiad*.)

Bill Moos, shown here as "King Biceps," was a leading player for the OHS football team the first year it played in Ingersoll Stadium. He went on to be the 1972 team captain and an All PAC-8 player for Washington State University. He later served as athletic director for Washington State University and the University of Montana. He retired as athletic director of the University of Oregon. (Courtesy *The Olympiad*.)

Jocelyn Dohm was salutatorian of the class of 1936 and editor of the *Olympus*. She went on to run her own printing company, The Sherwood Press, which operates from a 1940s building on Olympia's west side today. Here we see her grade report for 1933, which is signed by her mother. (Courtesy Jammi Heinricher and The Sherwood Press, Jocelyn Dohm Collection.)

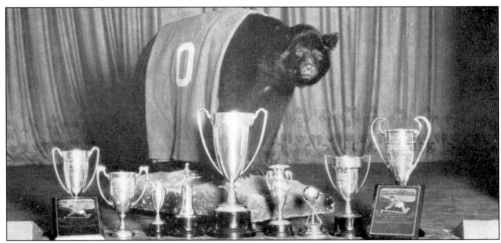

While taxidermy is out of favor in modern times, somehow the idea of having an actual bear, stuffed and preserved for posterity, as a mascot seems perfectly natural to generations of OHS alums. Here we find an early Pepper guarding some very impressive trophies in 1931. Later generations thought the passive position of this bear, which was used through the 1950s, was not befitting of the ferocity of the school's competitive teams. After this bear was retired, his successors were positioned on their hind legs, with paws outstretched and more menacing looks upon their faces. (Courtesy *Olympus*.)

Three

CLASSES, ACADEMICS, AND CO-ACADEMIC PURSUITS

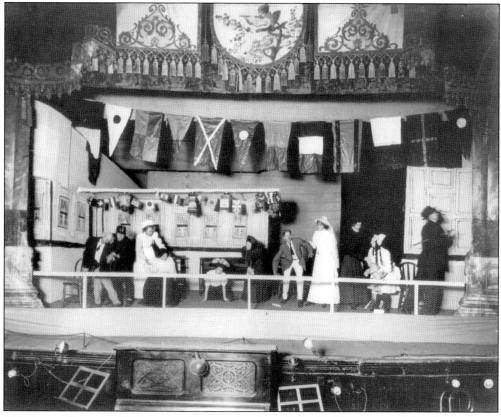

This image from the 1909 senior class production of *The Stubbornness of Geraldine* shows a view of the stage in the Twelfth and Columbia school building. The students on stage are Wallace Mount, Herbert Hoke, Sarah Waldrip, Clarence Butler, and Lovina Wilson. Wilson (seated) was also the editor of the 1909 *Olympus* magazine and yearbook. (Courtesy Washington State Historical Society.)

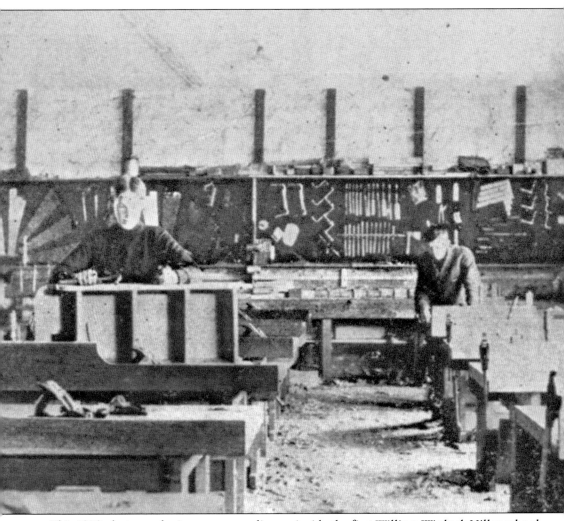

This 1909 photograph gives us a rare glimpse inside the first William Winlock Miller school. While some OHS students of that era went on to state colleges, most found practical vocations or worked for local businesses. The wood shop in the basement of the first school building was one of the gems of the school, turning out quality craftsman furniture that is probably still kicking around town in spare bedrooms and antique shops. (Courtesy *Olympus*.)

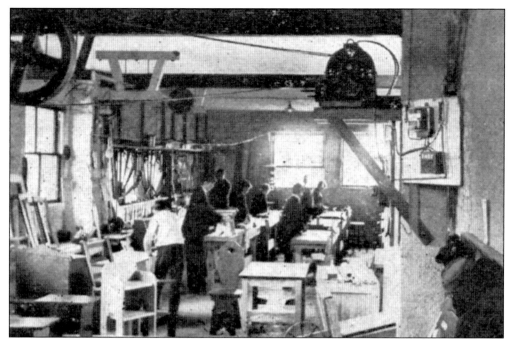
The Alaska Yukon Exposition in Seattle, arguably bigger in its time than the 1962 World's Fair, featured all of the modernity that Washington State could muster. OHS had the most respected wood shop in the state, and these students are likely putting finishing touches on items to be displayed in the Education Pavilion. (Courtesy *Olympus*.)

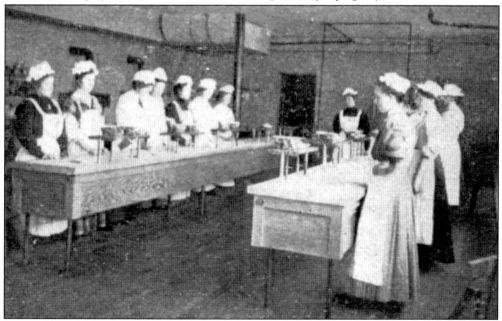
Domestic science classes eventually gave way to home economics, but learning proper housekeeping, sewing and mending, and cooking were important to women of the period. Female students were also involved in student leadership, the *Olympus*, sports, and dramatics alongside the boys. (Courtesy *Olympus*.)

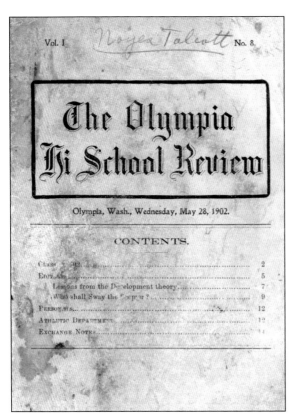

The *Olympia High School Review* was the precursor to the *Olympus* and is the oldest student publication in Washington State history. This is the oldest known copy, printed in 1902. It was donated to the Olympia High School Archives by descendants of its original owner, Noyes Talcott, who, as a jeweler's son, was the first student to drive a car to school. The *Olympus* has been in publication consistently since at least 1905. (Courtesy Olympia High School Archives.)

This 1911 commencement program is a great example of the format still used today. The outstanding young men and women in this graduating class were seated in the resplendence of the Olympia Opera House, with its rich red walls and curtains, rather than at St. Martin's Pavilion, with its institutional taupe walls. Graduation has been held at St. Martin's Pavilion almost every year for more than two decades. (Courtesy Olympia High School Archives.)

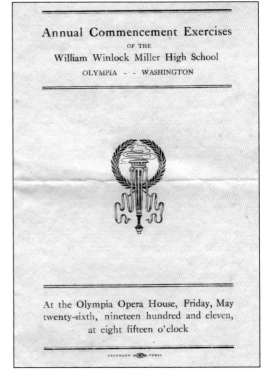

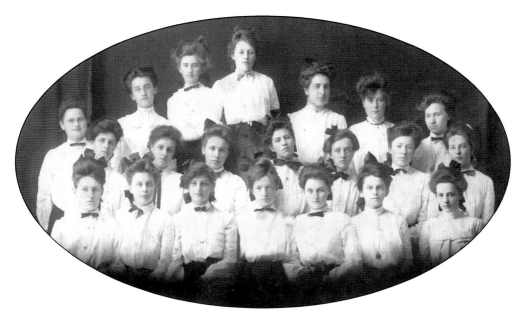

The Olympia High School Glee Club is shown here in 1906. One notable member is Viretta Talcott, daughter of one of Olympia's preeminent citizens and jewelers. (Courtesy Olympia High School Archives.)

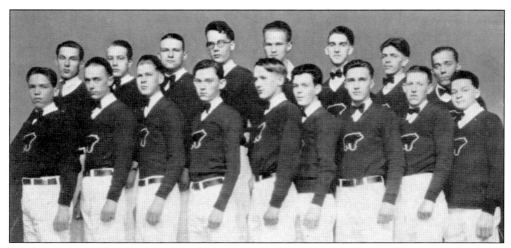

While many people who lost their life savings had little to sing about after the stock market crash in 1929, the boys glee club, shown here in distinctive bear sweaters, were surely singing a happier tune.

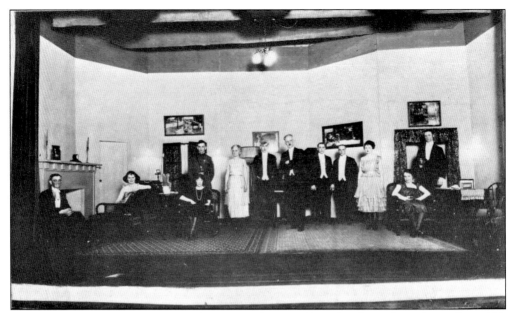

Lavish plays were a mainstay at Olympia High since the school's earliest days. This 1922 senior class production of A. E. W. Mason's *Green Stockings*, based on a 1916 movie by the same name. Each class put on a performance each year, and the school also had a drama club that presented plays. (Courtesy *Olympus*.)

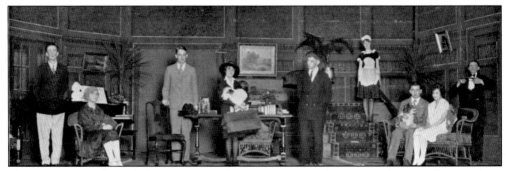

The 1928 junior class production of *Peg O' My Heart* starred, among others, Wallace Mills as "Jerry," Clara Louise Schmidt as "Mrs. Chinchester," and William Dye as "Jarvis the butler." (Courtesy *Olympus*.)

The *Olympus* is the oldest student publication in the state, and over the years it has garnered high praise for its fine writing. Originally a quarterly publication, in the 1920s it was published every two weeks, and then it became a weekly publication. This 1918 art nouveau cover is one of the finest examples of cover art from the early days of the publication. Editors were chosen for each semester, but many served both semesters. The *Olympus Commencement Edition* eventually gave way to the *Olympus Annual*, which was later named the *Olympiad*. (Courtesy Olympia High School Archives.)

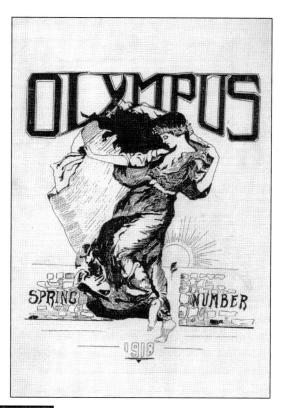

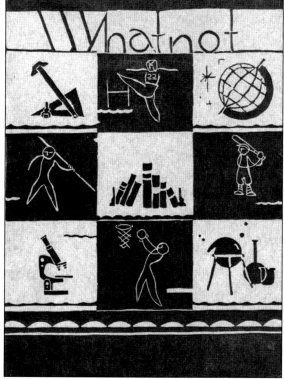

The *Olympus* was well established by 1929 when an upstart literary magazine, the *Whatnot*, was published at OHS. It is unclear when the *Whatnot* was last published, but it was definitely still in production during the mid-1940s. The cover of this issue from 1940 is a woodcut design, and all of the pictures carried a similar theme. (Courtesy *Olympus*.)

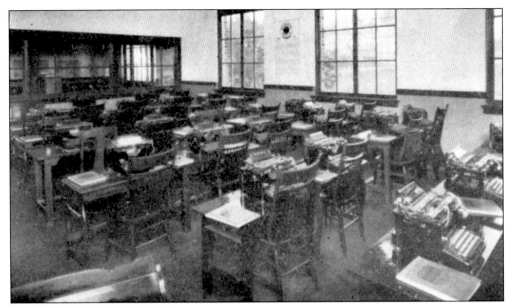

The school underwent a major expansion in 1926, just eight years after it opened. There was great pride over the new, modern amenities, including the typing classroom shown here. This image comes from a school rededication flyer, which, while not as clear as one might hope, offers an interesting perspective. Notice the chairs, which are very aesthetically pleasing, even if they are not ergonomic by today's standards. (Courtesy Olympia High School Archives. Donated by Winnifred Castle Olsen, '34.)

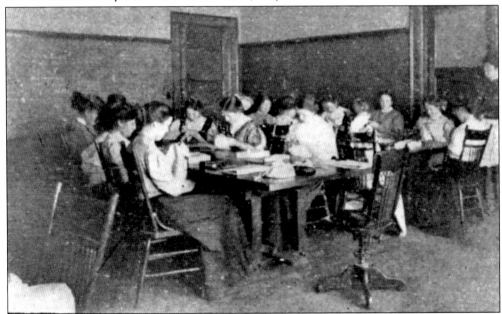

This photograph, taken about 1909, shows the domestic service classroom in the Twelfth and Columbia school. The classroom was institutionally furnished, with chairs and a table that might be a hit on the Antiques Roadshow today. Here students work on sewing and needlepoint projects, most likely for presentation at the Alaska Yukon Exposition in Seattle. (Courtesy *Olympus.*)

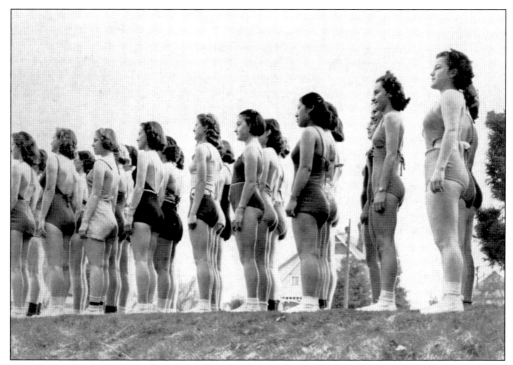

Everyone who has a grandmother of a certain age has heard that correct posture should be "chest out, shoulders back, and chin in." What we may not have known was that this aesthetic was a major focus of women's physical education in their schools. This 1938 photograph of a physical education class on the campus of the state capitol demonstrates just how much emphasis was put on a woman's posture. (Courtesy *Olympiad*.)

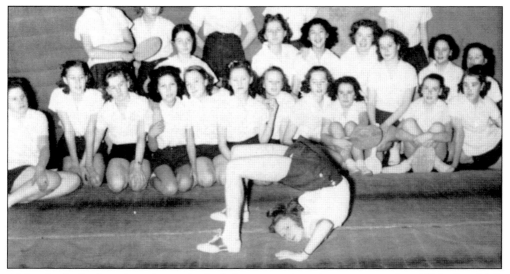

Girls physical education classes included gymnastics, ping-pong, and paddleball, which was played over a net, much like volleyball. This girls gymnastics class exhibits fine form in 1940. (Courtesy *Olympiad*.)

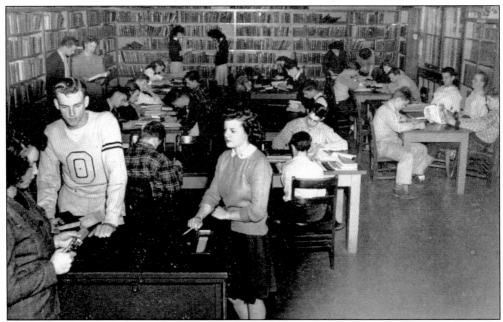

The library at the Capitol Way campus was small by modern standards, but the close quarters do not seem to be much of a problem for these enterprising students in the 1940s. (Courtesy *Olympiad*.)

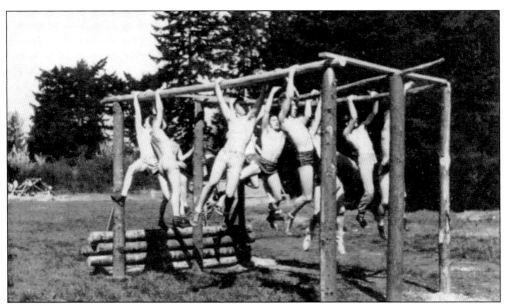

In 1943, a requirement of the War Department forced every able-bodied male high school senior out of bed earlier than usual to participate in Commando Physical Education. The government, assuming that these young men would be next year's recruits, wanted them in fine form. Homer Fulton of the Olympia YMCA served as drill master over the bare-chested students. It was noted that, given the difficulty of the course, the men were pretty well roughed up by the time class started. The course was built by students out of natural materials. (Courtesy *Olympiad*.)

This ASB card was issued to Bette Eads for the 1944–1945 school year. The cards, which served as students' tickets to the world of Olympia High School athletic events and dances, were introduced in the 1930s and were used for decades. (Courtesy Maguire family.)

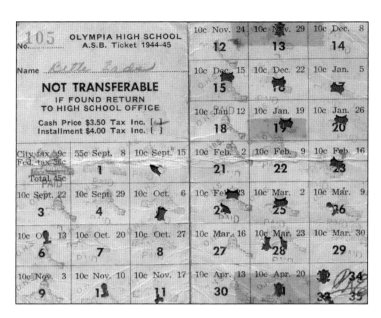

Decades before the passage of the Equal Rights Amendment, the men of Olympia High School were bending traditional gender roles. Seen here in the home economics room in 1946, these students, looking much like characters from the movie *Grease*, were taught "the gentle art of cooking under the kitchenship of Miss Velma Hill." (Courtesy *Olympiad*.)

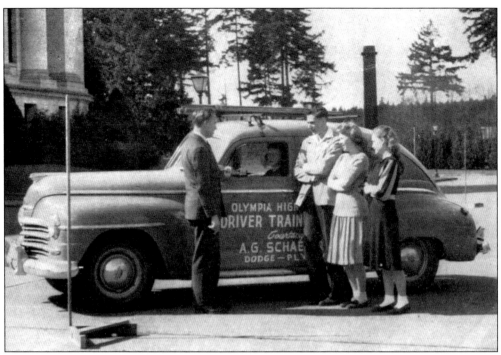

Students are pictured here receiving driver training instruction on the Capitol Campus in 1948. (Courtesy *Olympiad*.)

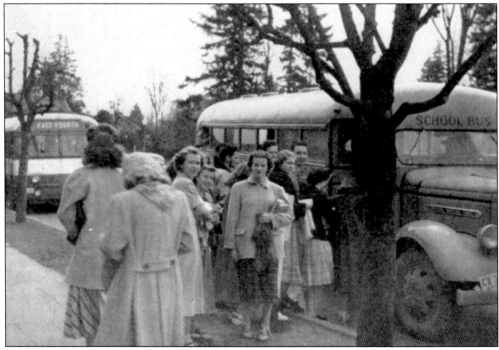

Daily activities that no one thought much about at the time, such as boarding school buses, look interesting almost 60 years later. Here is a glimpse of students getting onto buses outside of the Capitol Way school in 1950. (Courtesy *Olympiad*.)

This is a program for the 1951 junior class production of *The Late Christopher Bean*. Class plays continued through at least the mid-1950s. (Courtesy *Olympiad*.)

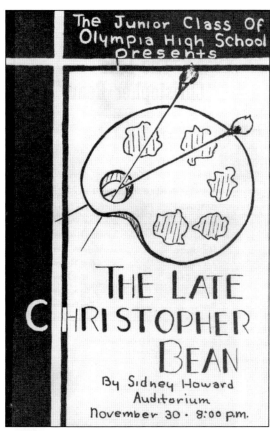

Typing classes in 1957, long before the advent of the home computer, were the domain of women, and this class is no exception. While International Business Machines was building the first computer for the Defense Department at this time, it is likely that these typewriters came from Smith Corona, whose Smith Tower is still the first grand building one sees when entering Seattle from the south. (Courtesy *Olympiad*.)

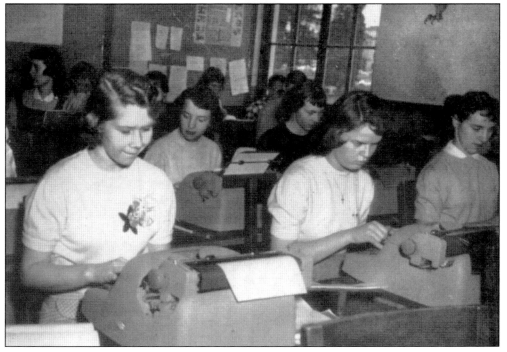

The *Olympus* staff of 1930 works hard at a wooden desk on the Capitol Way campus. (Photograph by Vibert Jeffers; courtesy Washington State Archives, Susan Parrish Collection.)

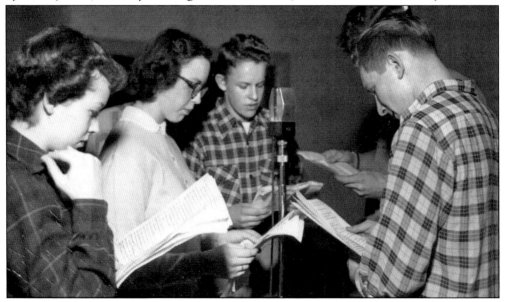

A decades-long partnership between local radio station KGY and Olympia High School allowed students to try out their on-air skills and provided them with a connection to the South Sound's most popular radio station in the 1950s. (Courtesy Olympia High School Archives.)

Commencement Exercises

William Winlock Miller High School

Olympia

THURSDAY, JUNE 6, 1957

8 P. M.

High School Auditorium

ADMIT ONE NOT GOOD AFTER 7:45

This is a 1957 admission ticket for the 50th graduating class. Weeks later, students participated in the first-ever Lakefair celebration, which has grown into the city's largest annual parade and fair. (Courtesy Olympia High School Archives.)

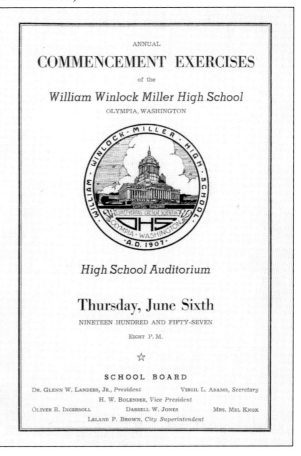

This is the commencement program for 1957, the year of the school's golden anniversary. The school seal was designed 30 years earlier by Dudley Dohm in 1926. Notice the details on the state capitol that do not exist on the actual building. The image of the capitol was taken from an artist's rendition prior to the building's completion. (Courtesy Olympia High School Archives.)

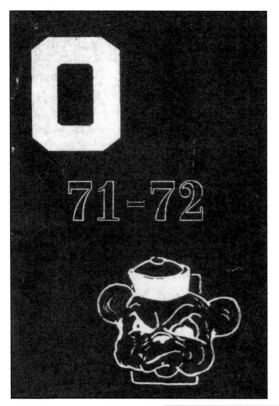

The "O Book" was given to each student at the beginning of the school year for at least 50 years. This small book listed class offerings, school rules, clubs and their officers, the officers of ASB and of each class, and the school floor plan. This example from the 1971–1972 school year also shows the official school bear that was used for decades. (Courtesy Olympia High School Archives.)

When the new Olympia High School opened in 1961, the language lab, shown here with R. C. Anderson teaching, gave students the opportunity to listen to the foreign languages that they were studying at their own pace, allowing for a more individualized learning experience. (Courtesy Olympia High School Archives.)

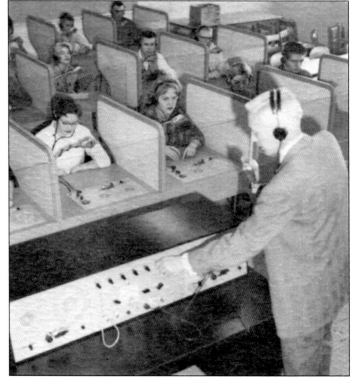

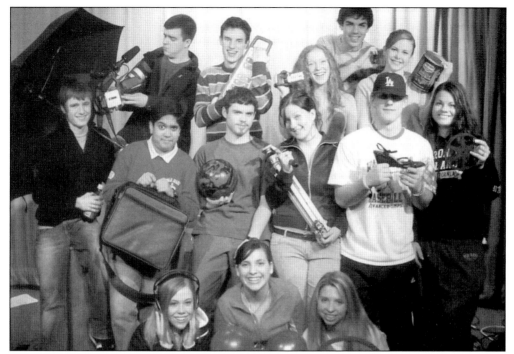

The Olympia News Network was established by Jeff Waddington in 1987 as a new way for students to report on school, local, national, and international events. The biweekly program celebrated its 20th year in 2007 and is going strong. Here the ONN staff of 2005 poses playfully for the *Olympiad*. (Courtesy *Olympiad*.)

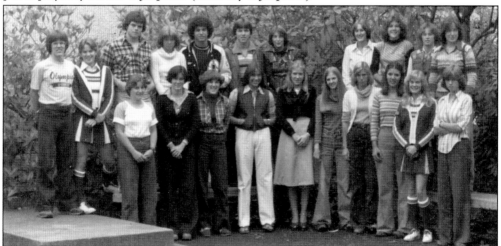

The notion of student government suffered badly during the wild antiestablishment years of the early 1970s, until Vice Principal Dale Herron advocated for elections of ASB officers (the first in years) and the creation of a student government class. The class was designed to give student leaders a time to work together to plan events, assemblies, dances, and other nonacademic affairs of the student body. Unlike the student senate, this group continues to meet as a class, and it is a partner with faculty and administrators in maintaining the excellence of student events and traditions. Seen here is the first student government class, looking very much a product of the disco area, in 1978. (Courtesy Olympia High School Archives.)

The ABBA-esque Good Day singers, shown here in 1975 at the Olympia waterfront, were a staple of the music program under Karla Timmerman, who oversaw the string and vocal groups at OHS for decades. The group performed choreographed routines while singing classic and contemporary songs. Most of the Good Day singers could have walked right onto the set of the Lawrence Welk show and felt right at home. (Courtesy *Olympiad*.)

Four

FUN TIMES
DANCES, PLAYS, FESTIVALS, AND DEBAUCHERY

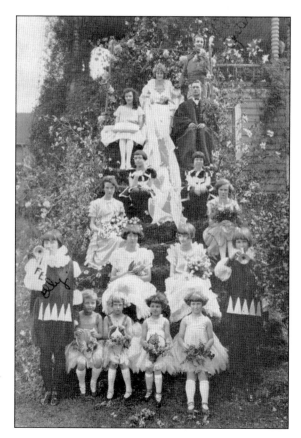

May Dance is the oldest remaining tradition at Olympia High School. Originally an all-school formal dance, it has evolved into the annual senior prom. A May queen was elected by the students as early as 1917, maybe earlier; but it was not until the community began a May Fete celebration that the election of "royalty" became a major school event. This photograph from 1924 shows May queen Catherine Redpath with her entourage of high school princesses and other attendants from the Washington and Lincoln Schools. In the upper right corner, court jester Jerry Kelley makes merry while the rest of the court basks in the glory of the moment. (Courtesy *Olympus*.)

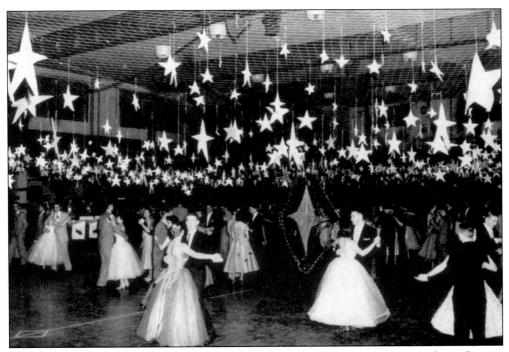

This image of the 1956 junior-senior prom, held in the OHS gymnasium, provides a glimpse of the glamour and pomp of the time. A clever net strung from both sides of the upper seating area transformed the room, allowing for the stars to be closer and making the room seem less cavernous. The dresses are something one would only imagine at a debutante ball today. (Courtesy *Olympiad*.)

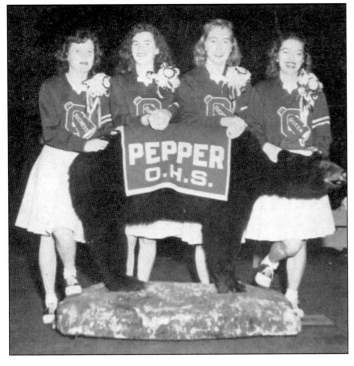

The song staff rest atop Pepper in 1948. (Courtesy *Olympiad*.)

Mattson, Adv. Martha Strange Mary Kelly Jerry Gregor Dorothy Windell Virginie Peters Juel Gregor Bette Eads Barbara Schroeder
...lyn Smart Betty Kornmesser Virgene Wade Dixie Haugen Patt Medbury Audrey Strandness Joan Miller Bernadette Campbell
...rma Simila Donna Hedwall Jerry Hjelm Betty Stevens Madge Brown Shirley Williams Helen Clausen Virginia Rydman Jo Downs

Many clubs came and went over the years, but the YMCA Hi-Y Club for boys and the YWCA Tri-Y Club for women endured for a number of decades. Large groups of club members often put on social events, off-campus dances, and provided community service. This photograph shows that the group was going strong as World War II came to an end. (Courtesy Maguire family.)

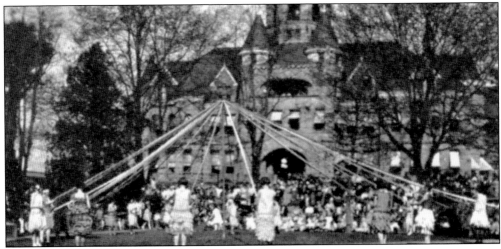

This 1925 photograph shows the third annual May Fete held at Sylvester Park. This city-wide festival has been all but forgotten; the annual May Dance at Olympia High is the only remaining tradition. Capitol, Tumwater, and North Thurston High Schools also refer to their annual proms as the May Dance, which is not a coincidence, given that these are all offshoot schools of OHS. (Courtesy *Olympus*.)

Beautifully decorated tickets such as this one were sold to students before the May Fete and, later, the May Dance. The school did not always use a voting system to choose royalty as it does today; the early spots were once up for sale. Proceeds from the sale of May Queen tickets were used to benefit the school, and in 1924 they built the school's first tennis court at Stevens Field. (Courtesy Olympia High School Archives.)

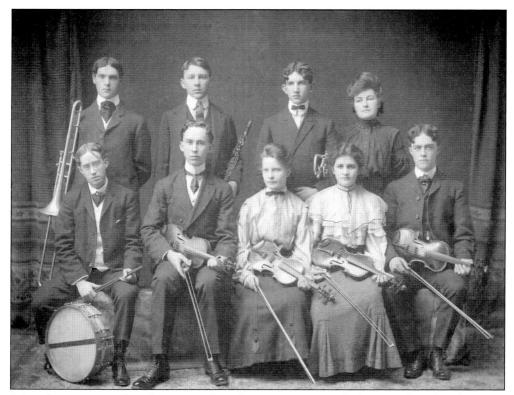

It is safe to assume that this image, found among a group of photographs taken between 1907 and 1909, is among the earliest remaining photographs of an Olympia High School band. (Courtesy Washington State Historical Society.)

The 1930 band is ready for action. The drum was clearly meant to be carried while marching. (Courtesy *Olympus*.)

This hand-designed card with original photographs gives a glimpse of how much work went into the layout of the 1927 *Olympus*. (Courtesy *Olympus*.)

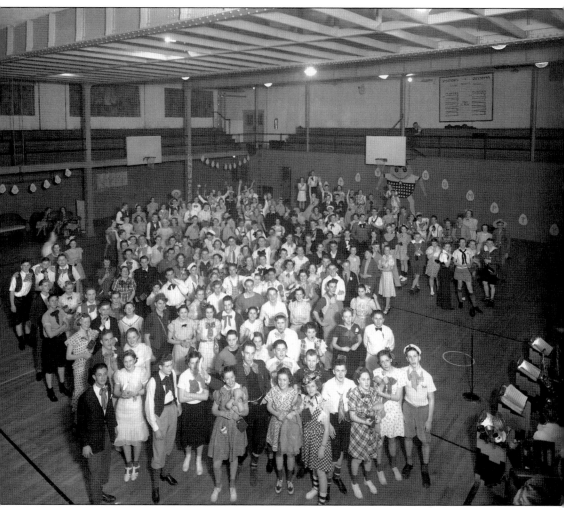

Students attending the 1937 All Kid Dance, held in the Olympia High School gym, pause briefly for a group photograph. This is one of the clearest pictures of a dance on record. The big band in the lower corner must have been kicking up quite a set of tunes, because everyone looks as though they are having a great time. (Photograph by Vibert Jeffers; courtesy Washington State Archives.)

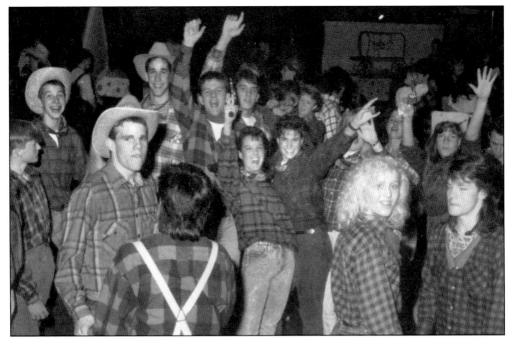

Sadie Hawkins was introduced as a cartoon character in 1937 in the comic strip *Li'l Abner*, and the 35-year-old "spinster" quickly won the hearts of women and men alike. Given that Sadie and her family were hillbillies and that she was always desperate to find a man, Sadie Hawkins dances are girls-ask-guys events and generally have a hillbilly or Western theme. Here we see a cast of characters looking very much the part in 1989. The Sadie Hawkins dance became an annual fund-raiser for the senior class in 1964. (Courtesy Washington State Archives.)

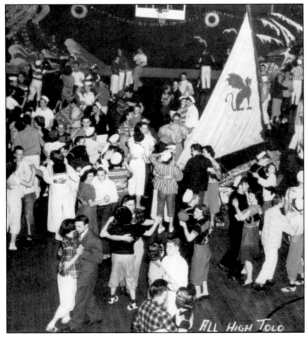

Ahoy! The maritime theme of the 1950 All-Hi Tolo was a spirited postwar homage to the boys in uniform who sailed the seas to protect our country. (Courtesy *Olympiad*.)

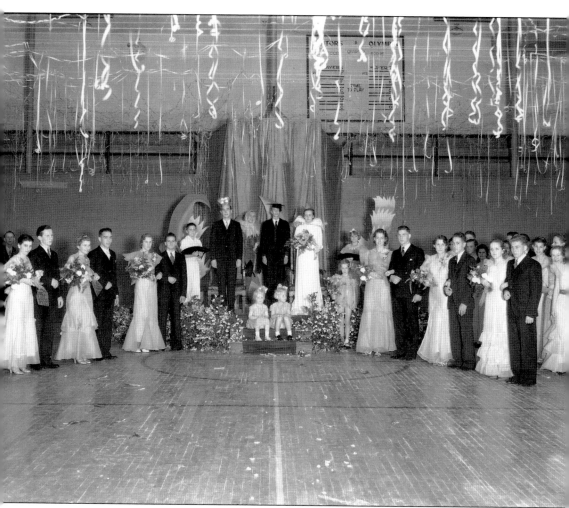

For generations, the members of the May Court have lined up before their subjects for formal photographs such as this one, taken in 1934. In later years, these photographs were often taken on the campus of the state capitol. Due to early print deadlines for the yearbook, these images dropped out of decades worth of written and photographic history. Here are Queen Barbara Fairchild and King James Carpenter accepting the adoration of their subjects during the evening of the dance, with the court jester, prime minister, and attendants in waiting at their sides. Two notable attendants were Dorothy Castle (first to the right of Barbara) and her sister Winnifred Castle (Olsen) to her right. (Courtesy Washington State Archives, Susan Parrish Collection.)

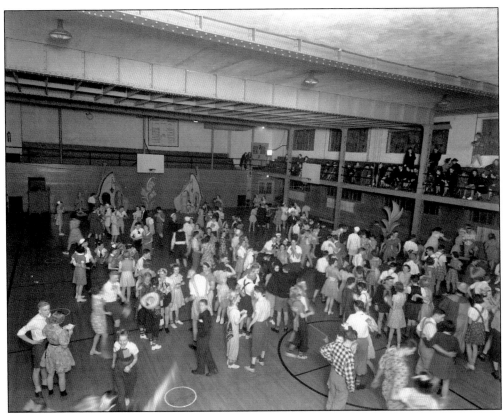
The Tolo Dance held in 1938 used decorations from a previous class play and featured his and hers outfits. (Photograph by Vibert Jeffers; courtesy Washington State Archives, Susan Parrish Collection.)

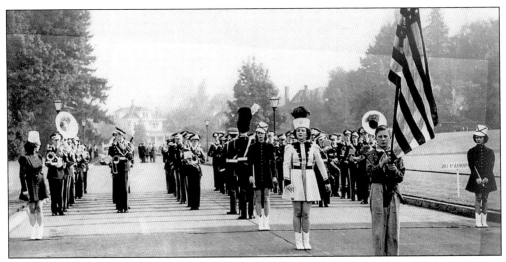
The OHS Marching Band, led by Bette Eads Maguire, performed for Pres. Harry Truman on the steps of the state capitol in 1945. (Courtesy Maguire family.)

Students of the 1940s and 1950s have fond memories of the YMCA-hosted Bear Den, an off-campus dance hall where they could kick it up and have a brush with the independence of adulthood. While it was not sanctioned by the school, the fact that the Bear Den was named for the school's mascot strongly suggests that it was a place where OHS students could feel at home. The Bear Den moved from the basement of the downtown YMCA to a warehouse space on Legion Way, which is now used as storage for the Fish Tale Ale Brewery. (Courtesy Olympia High School Archives.)

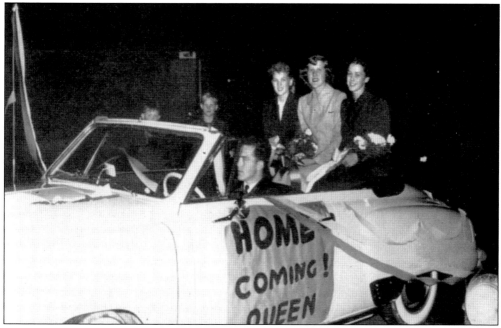

The first homecoming queen, Donna Voegelein, is shown here arriving at Stevens Field in the fall of 1949. Early queens and princesses saved their formal gowns for the night of the dance. Today they are debuted to students at the homecoming assembly and to the general public at the football game. (Courtesy *Olympiad*.)

```
         CORRIDOR PERMIT
Student Jocelyn Dohm  Date 5/9
Time Lvg.____ Teacher Erickson_____
L'try____ Office____ Room No._____
Special   Permanent_____
Time Rtd.____ Teacher_____
This slip to be returned to teacher who
issued it.
```

Something as mundane as a hall pass becomes a unique piece of ephemera when it is stored away in a scrapbook for 50 years. This is Jocelyn Dohm's "permanent" corridor pass from the 1930s. (Courtesy The Sherwood Press, Jocelyn Dohm Collection.)

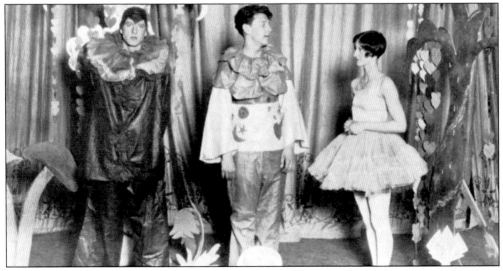

Olympia High School joined in a one-act play competition with Aberdeen High School and Hoquiam High in 1929. Pictured here are cast members from OHS's production of *The Heart of a Clown*. Evadne Gifford played Columbine, Wallace Mills played the clown, and Carl Reder played Harlequin. (Courtesy *Olympus*.)

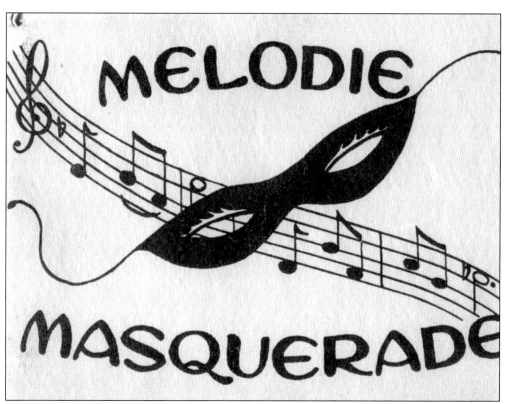

The 1955 Tolo theme was "Melodie Masquerade." Couples donned his and hers outfits for this zany masquerade ball. A Tolo is, by definition, a girls-ask-guys dance. Along with Sadie Hawkins, it balanced the burden on the fairer gender. Young men made the invitations to Homecoming and the May Dance. This is a dance card with lines for a young lady to list the men she danced with or the dances they performed. (Courtesy Deena Harbst Chase.)

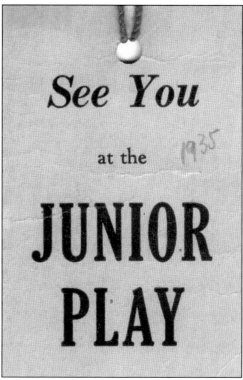

For decades beginning in the early 20th century, students in each class put on an annual class play. This 1935 announcement for the junior play is typical of the publicity items used to promote the events. (Courtesy Olympia High School Archives.)

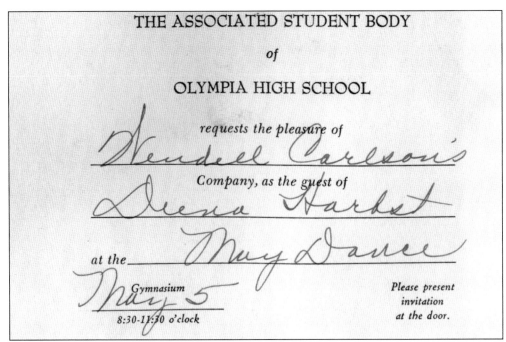

In 1955, you did not just ask someone to a May Dance—you sent them a formal invitation. This is an invitation from Wendell Carlson to Deena Harbst. She accepted it as well as, later, his marriage proposal. The invitation also served as a ticket for admission to the dance. (Courtesy Deena Harbst Chase.)

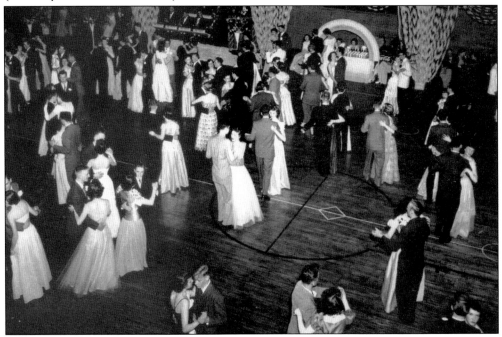

The 1950 junior-senior prom looks like something out of *I Love Lucy*. But while the decorations are excellent, there is no mistaking the OHS gymnasium for Club Babalu. (Courtesy *Olympiad*.)

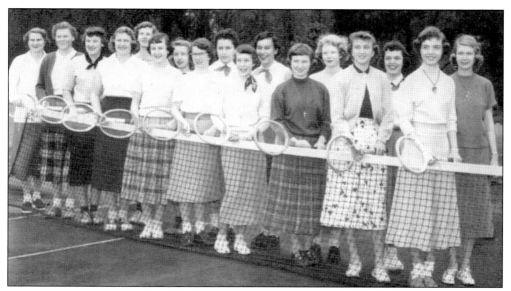

The members of the 1953–1954 girls tennis team were pioneers for women's competitive sports. Coached by Shirley Kammeyer, they had a great season, beating archrival Aberdeen as well as Chehalis, Centralia, and Shelton. The OHS tennis court was located at Stevens Field in the 1950s. (Courtesy *Olympiad*.)

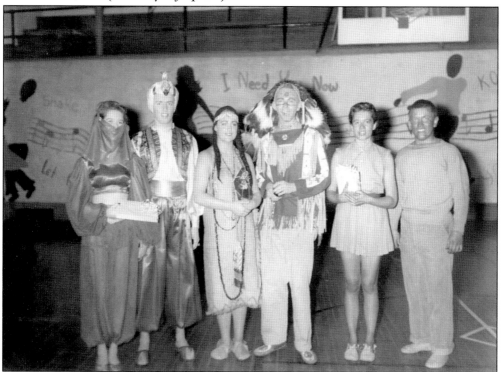

Deena Harbst, Wendell Carlson, Sonya Christopher, Jim Kelley, Linda Christopher, and John Brassfield are seen here in their his and hers costumes at the 1955 Tolo. The theme for the year was "Melodie Masquerade," which seems like a lot more fun that the basic formal that the Tolo evolved into. (Courtesy Deena Harbst Chase.)

Until recently, Olympia High School has had a grand marching band program. Shown here is the 1950 marching band at the Centennial Parade along Legion Way. The photograph almost dates itself: the scaffolding for the repair work done after the 1949 earthquake is still clearly visible on the capitol dome. (Photograph by Merle Junk; courtesy Washington State Archives, Susan Parish Collection.)

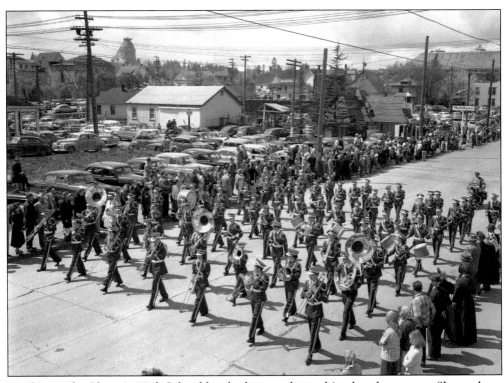

The Olympia High School Rock is shown here in the 1980s. A popular myth is that it started out as a pebble but, with subsequent coats of paint, has grown to over six feet long. Found in 1962 during landscaping work, the rock has given generations of students a canvas for expression about everything from birthdays and teenage crushes to encouragements for teams other than the Bears. Messages may last anywhere from an hour to weeks, but those that include the words "Go Cougs!" are sure to be quickly covered. The original rock was removed after vandals painted it repeatedly, but Dirk Smith ('80) loaded this one from a nearby quarry into his stepfather's truck and dumped it on the grass in the student parking lot, and it was quickly painted by his classmates. When the school was remodeled in 2000, this rock was bulldozed into the wooded area around the pond, where it remains today. (Courtesy *Olympiad*.)

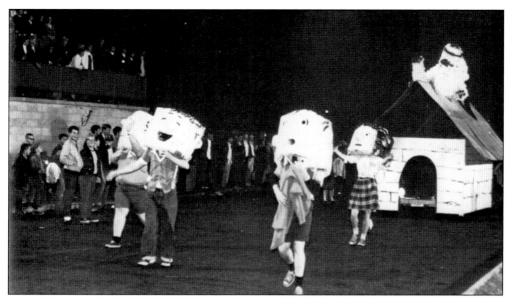

Charles Schultz's Snoopy was the inspiration for this senior float, pictured at the homecoming game halftime show in 1968. This float won first place in the voting. (Courtesy *Olympiad*.)

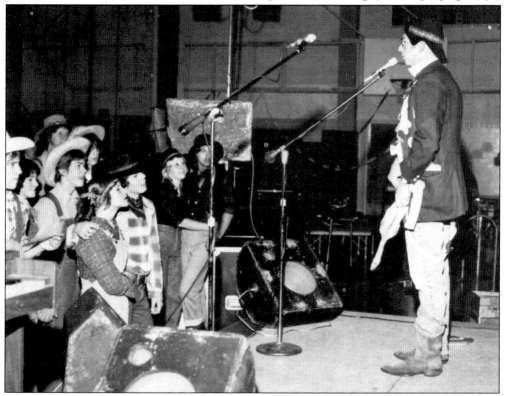

Live bands at high school dances are almost a thing of the past today, but from the early days of OHS right through the 1980s there were few dances without live performances. The 1979 Sadie Hawkins Dance was no exception. The students, dressed in traditional hillbilly attire, look like they are having a hoot 'n' hollerin' good time. (Courtesy *Olympiad*.)

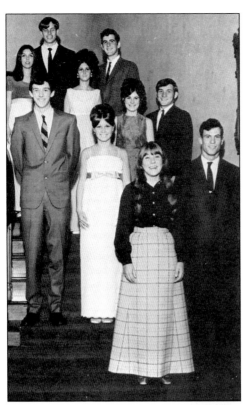

Here we see 20-plus-year veteran teacher Scott Rutledge (on the left, with the striped tie) feeling confident that he will be crowned king. He was reduced to eternal princedom when King Eric Hanson and Queen Teri Ramsauer (first row) were crowned. (Courtesy *Olympiad*.)

This image, unimaginable in today's world, shows the 1978–1979 Gun Club in Chick Rockey Gymnasium, looking quite ready to go out on a hunt. The advisor is Pete Strobl. (Courtesy *Olympiad*.)

As drum majors go, Brian Cole looks pretty standard in his cap and uniform in this 1969 image. Twenty years later, the uniform looked almost the same. (Courtesy *Olympiad*.)

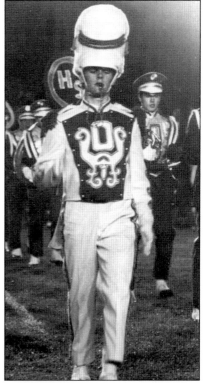

As the climate in America turned against religious displays in schools in recent years, the Christmas assembly, once a highlight of the year, has been toned down significantly. This scene from 1970, in which two seniors are selected as Santa and Mrs. Claus, is repeated to this day. The stunning aspect of the photograph is that they are riding not in a sleigh but in a car on the hardwood floor of Chick Rockey Gymnasium. (Courtesy *Olympiad*.)

Homecoming assemblies have not been the same since the tradition of the senior stripper was abandoned. A member of the football team, chosen in secret by his teammates, would enter the gym to the traditional striptease song played by the band. Students would go wild, and many would blush, as the player removed article after article of his uniform, throwing them into the crowd to screams and cheers. At last, wearing only his boxers (or, in the case of this 1975 senior stripper, Kevin Weiks, his briefs), the stripper would reveal his identity when he removed his helmet and flung it down the center of the gym, always to wild applause and laughter. (Courtesy *Olympiad*.)

Homecoming floats designed by each class were paraded around the stadium and subjected to a vote of the attendees as to which one was the best. This image of a float from 1970 is one of the best that remains. The designs and whereabouts of the class floats were a closely guarded secret, as sabotage by members of another class could ruin the float and its chances of winning. At various times, the homecoming court, the cheerleaders of each class, and the football players rode on them. The floats have been discontinued, victims of a litigious society, but in recent years there has been a movement to revive the tradition. (Courtesy *Olympiad*.)

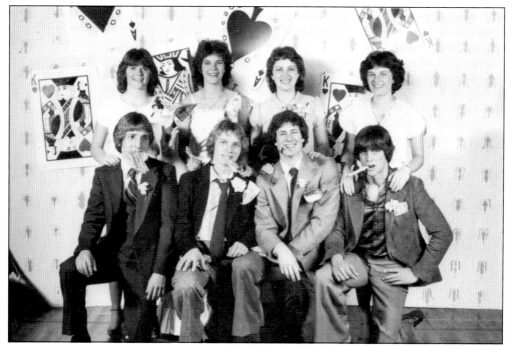

Fortunately for us, what happened at Tolo did not stay at Tolo in 1980. These students took the Vegas theme to a new level. In recent years, the Tolo has changed from a semiformal back into a his and hers costume theme dance. (Courtesy *Olympiad*.)

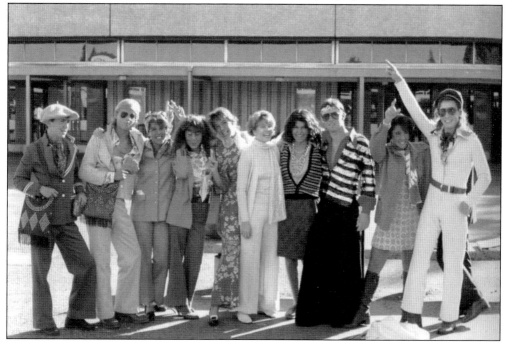

A big joke for students is that someday they will attend an event where the theme reflects the attire of the decade in which they graduated. Here we see an example of 1960s attire as envisioned by students in 1988. (Courtesy *Olympiad*.)

After the school's reconstruction in 2000, a new rock was bought and placed on campus. Larger than the previous two rocks, it provided an even more impressive canvas for members of the class of 2004. (Courtesy *Olympiad*.)

The drill squad at Olympia High School has gone through many phases, morphing into a dance team and then into a drill team. It is now lauded as one of the best in the state, and there is fierce competition to get on the team. Shown here is the 1995 drill squad. (Courtesy *Olympiad*.)

Five

THE SPORTING LIFE
ATHLETICS AND CLUB SPORTS

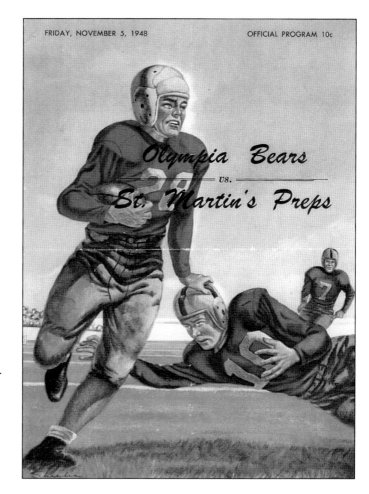

It has been decades since St. Martin's offered preparatory education, but in 1948 it was a crosstown rival of the Bears. This game program provides interesting visual documentation of the historic rivalry. (Courtesy Olympia High School Archives.)

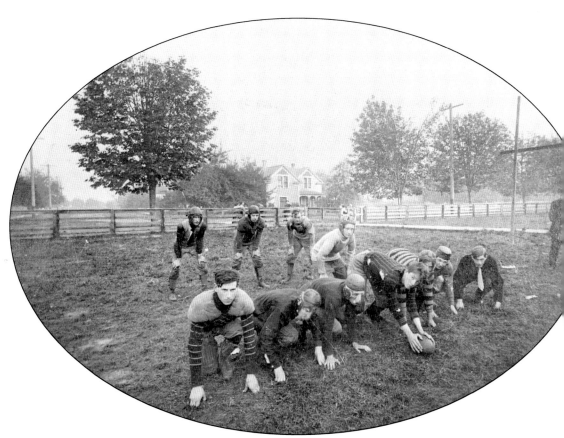

Posed here is the 1905 football team, looking more at the camera than at the play at hand. The athletic park where this photograph was taken was the predecessor to Stevens Field. (Courtesy Olympia High School Archives.)

The 2007 OHS track team, made up of hundreds of students, was one of the best programs in the state. In 1909, a much more modest showing of young men competed in many of the same running, jumping, and throwing competitions that we have today. (Courtesy Olympia High School Archives.)

The track team in 1910 was small and had a disappointing season, as three of their meets were canceled and they did poorly at the statewide championships.

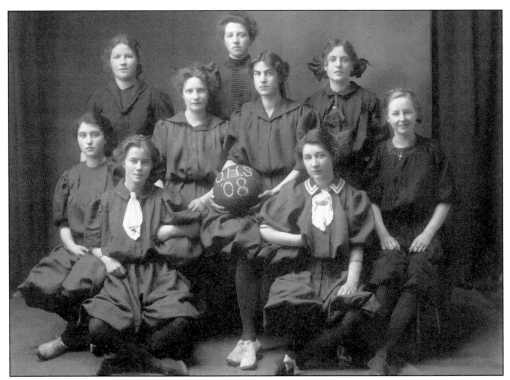

Interscholastic women's sports were prohibited by the school board for decades, but that did not quell the lively intramural program that has flourished at least as long as there are records of sports at the school. The competition for these ladies was limited to teams made up of members of other classes, but many of the early *Olympus* articles refer to the fact that there were lively contests and deep rivalries. One has to agree that this 1908 group of girls looks formidable. (Courtesy Olympia High School Archives.)

Women's intramural sports were a major part of student life in 1926 when 110 girls turned out to represent their classes in the volleyball competition. Shown here are the letter winners for the year. (Courtesy *Olympus*.)

Very little is known about the 1904 baseball team, but this shot, most likely taken at the athletic park, shows that the "boys of summer" were good representatives of their high school class. At the time, these students were attending their OHS classes at the Washington School with students of all ages. (Courtesy Olympia High School Archives.)

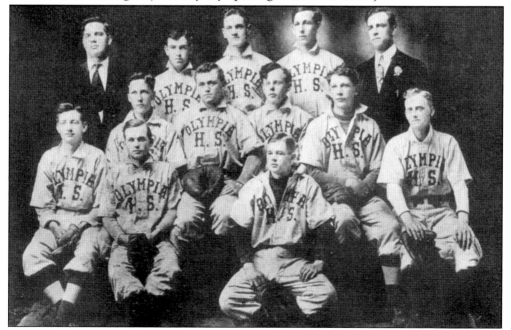

The 1911 baseball team won three games and lost three—but they were expected to lose the final game of the year, as they were challenged by a much more formidable foe: the University of Washington. (Courtesy *Olympus*.)

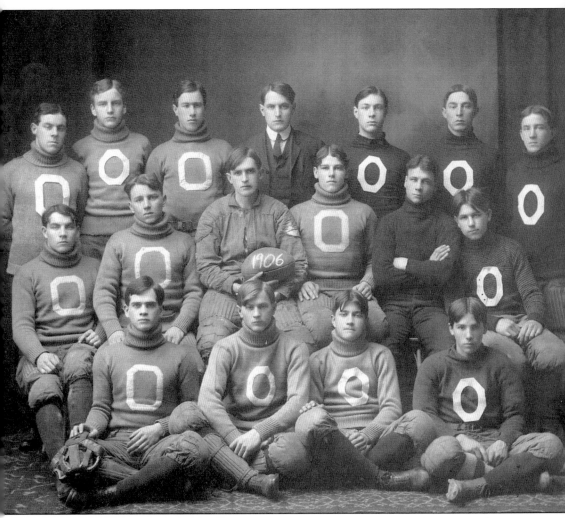

By the 1906–1907 school year, football was a tradition at OHS. That year's players were among the first students to attend classes at the first William Winlock Miller School. News about Coach George Bigelow's 1906 football team was often on the front page of the local paper. While Aberdeen High School seemed to be the really big rival, a cheer was featured in the October 20, 1906, *Morning Olympian* to get the rooters ready for a home game against Tacoma that evening. It read, "Sis! Boom! Bah! Olympia High School! Rah! Rah! Rah!" It was also mentioned that the Tacoma team and rooters would arrive by train that morning. These athletic young men do not look anything like the outsized players of today. (Courtesy Olympia High School Archives.)

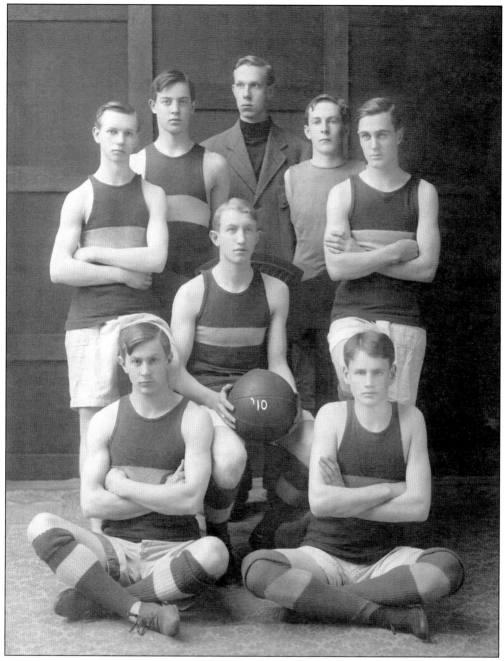

More is known about the classes of 1907 and 1909 than about the class of 1910, but this image of the young men of the hardwood could not be overlooked. (Courtesy Olympia High School Archives.)

A surprising number of early photographs of OHS football teams remain. This one is unique because it includes the 1911 team's unofficial mascot, "Heck." Notice that the Tenino sandstones flanking the front door of the first school building are very much like those found in the old state capitol building. (Courtesy Olympia High School Archives.)

This image, an interesting departure from the standard yearbook photographs of the early 20th century, shows the 1919 football team in action on the field, presumably at the athletic park. (Courtesy *Olympus*.)

A blue ribbon served as both a ticket and a show of support for the home team at the 1921 championship baseball game. (Courtesy Olympia High School Archives.)

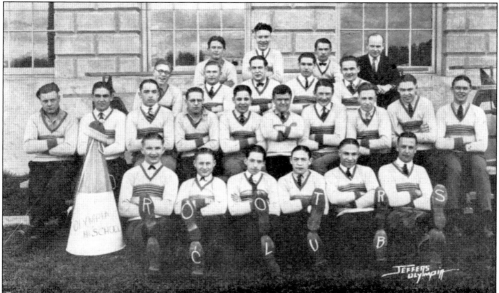

Early yearbooks gave much more of a written account of student life than more recent ones, and they often bemoaned the lack of school spirit that pervaded particular classes. The Rooter Club of 1923 clearly had no problem showing its support for the Olympia Bears. (Courtesy *Olympus*.)

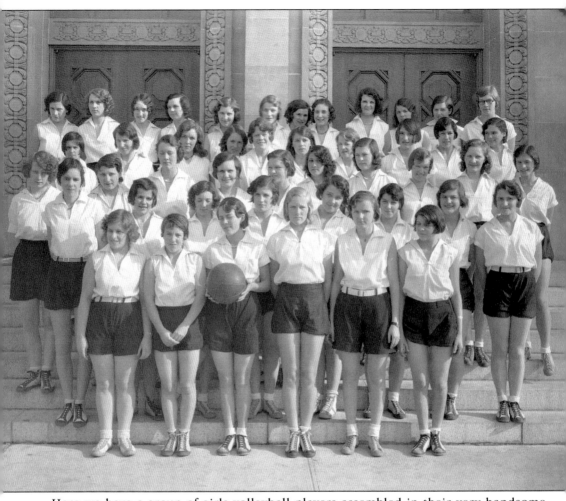

Here we have a group of girls volleyball players assembled in their very handsome uniforms in 1931. (Photograph by Vibert Jeffers; courtesy Washington State Archives, Susan Parrish Collection.)

The Knights of the Oyster, whose name paid homage to one of Olympia's best-known products at the time, the Olympia oyster, was a boys social service club that helped maintain the sports fields and the school grounds. Here club members help team managers prepare Stevens Field in 1931. (Courtesy *Olympus*.)

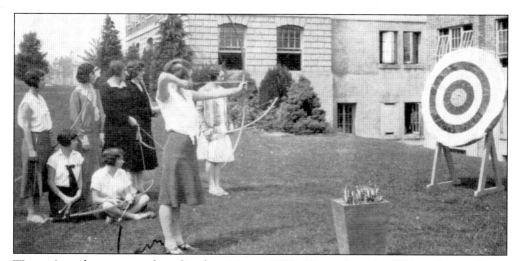

Women's archery was a short-lived activity at OHS. Shown here in 1931 at the southeast corner of the second school, these ladies seem to be quite intent on hitting the target. (Courtesy *Olympus*.)

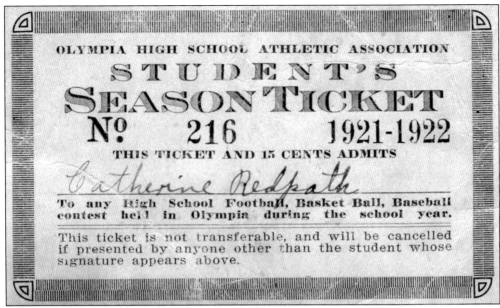

A 1921 Olympia High School student season pass could be had for only 15¢. This one is from the collection of Catherine Redpath, who was named May queen the following school year. (Courtesy Olympia High School Archives.)

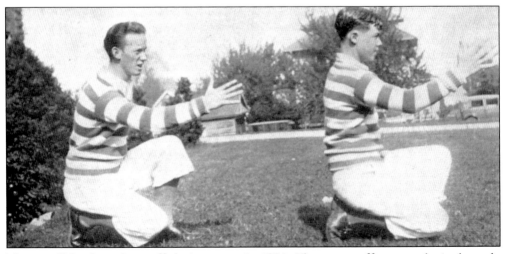

These yell leaders show off their moves in 1931. The pep staff was exclusively male for decades. Each class had a yell leader, and the senior class leader was the yell king. (Courtesy *Olympus*.)

The heading above this photograph read, "With a Cheerio and a Toot Toot." That just about describes the antics of the 1938 yell king on the right and the duke on the left. (Courtesy *Olympus.*)

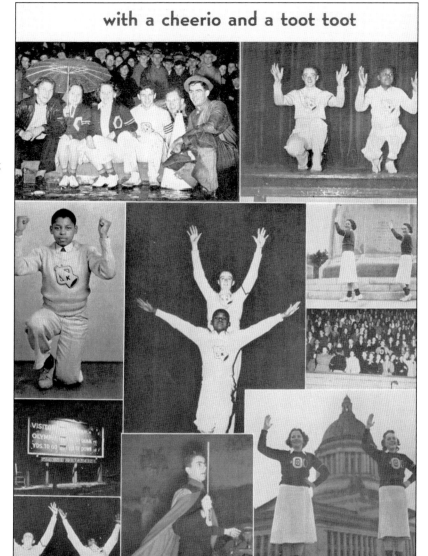

This 1920 basketball schedule shows that the first game of the season was with rival Aberdeen. A note on the bottom indicates that the team would play the College of Puget Sound (now University of Puget Sound). The team also played games against St. Martin's for many years. (Courtesy Olympia High School Archives.)

How Olympia High School gained access to the Larry Tisdale art in this 1948 football program is a mystery. Tisdale's artwork was used in the 1940s and 1950s in NCAA programs for the University of Michigan and the University of California, Los Angeles, among others. Today the best way to see his works is when they become available on eBay. (Courtesy Olympia High School Archives.)

The flying O made a great visual impact on the chests of these 1950 track athletes. Here we see Nathan Clifford, Ivan Budd, Fred Crow, and Denny Peterson clinging tightly to a baton. (Courtesy *Olympus*.)

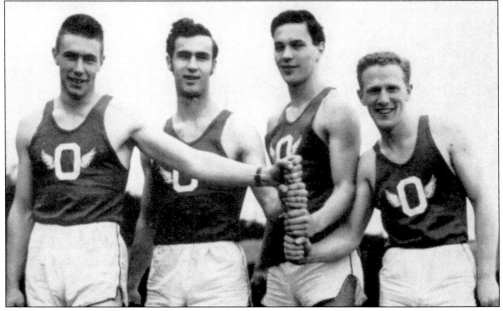

Jim Maguire (center) is seen here in 1946 with two teammates. (Courtesy Maguire family.)

The 1949 tennis team, shown here at the court at Stevens Field, was a modest group by today's standards. Dean Rockey is in the last row on the left side. (Courtesy *Olympiad*.)

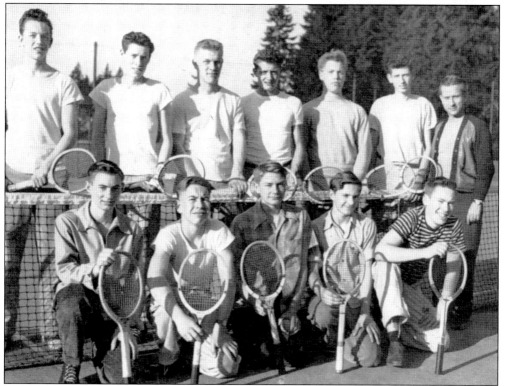

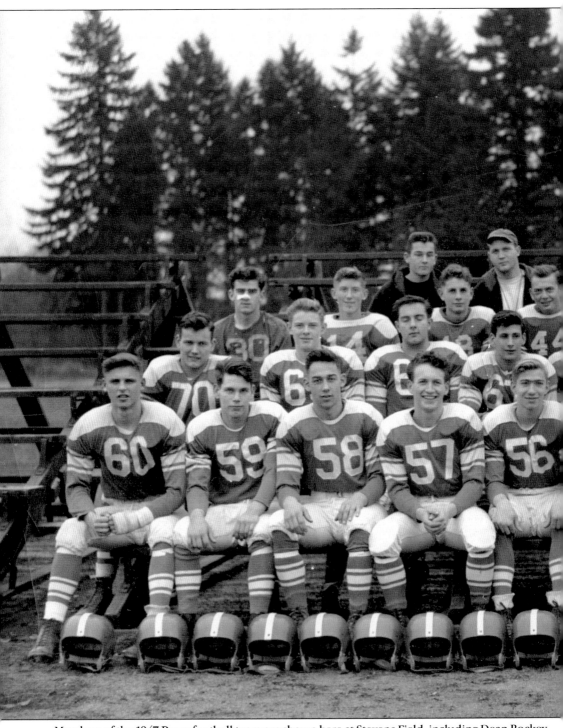

Members of the 1947 Bears football team are shown here at Stevens Field, including Dean Rockey

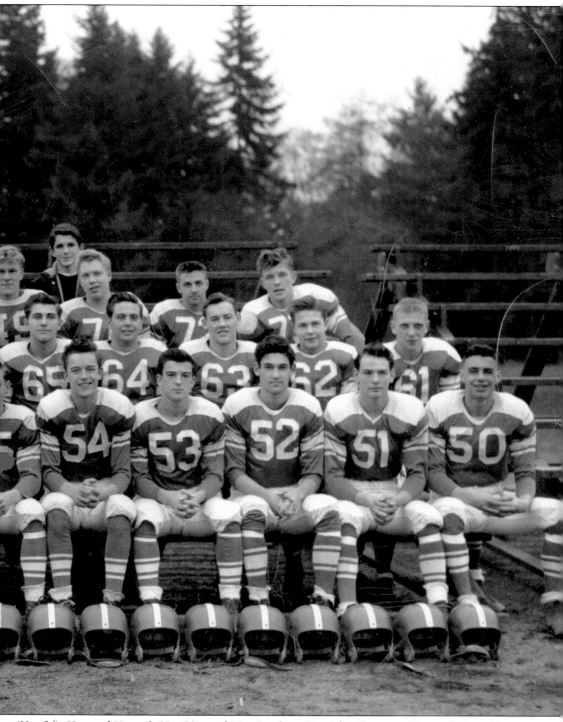
(No. 54), Howard Harpel (No. 50), and Mac Partlow (No. 14). (Courtesy Howard Harpel.)

OLYMPIA HIGH SCHOOL

This certifies that

_____JAMES MAGUIRE_____

has earned the right to wear this emblem

awarded in ____FOOTBALL____ season of 194_

Cameron Kyle
A. S. B. President

M. W. Rockey
Coach

Stan Bohle
Athletic Manager

A certificate with a blue O on it meant that you had been inducted into the elite Big O Club—the equivalent of becoming a letterman today. This certificate from 1946 commemorates the induction of James Maguire, the first of three generations of his family to attend Olympia High School. Chick Rockey was undoubtedly the man who signed the most certificates of anyone in the school's history, given his nearly 40 years as a teacher, coach, and athletic director. (Courtesy Maguire family.)

A 1956 football program was a big hit with fans of the Bears for only 15¢. (Courtesy Deena Harbst Chase.)

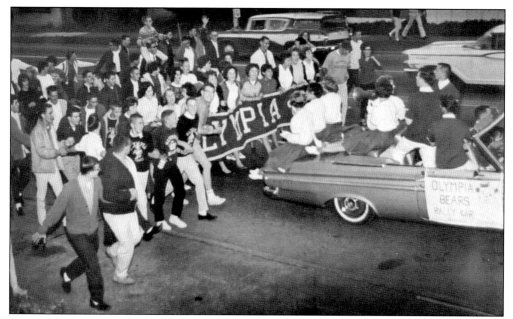

Spirit parades were a part of life for students from the 1940s to the 1960s. Students would march through downtown and, later, through the neighborhoods, singing cheers and carrying on. As time went on, fewer processions were held, marking only important games, such as homecoming. The parades died out altogether sometime in the 1980s. This one from 1961 looks particularly exciting, with the yell staff riding in the car and the spirited supporters marching behind with the banner. (Courtesy *Olympiad*.)

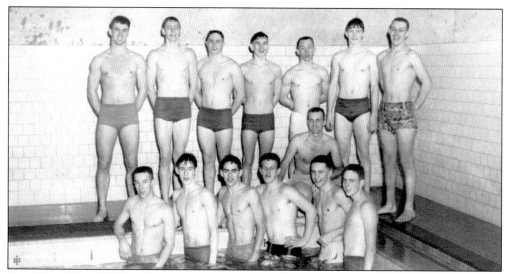

Coach Don Thornhill, kneeling at poolside, led the 1956 swim team to a state championship. Shown here are members of the victorious team at the Olympia YMCA. (Courtesy *Olympiad*.)

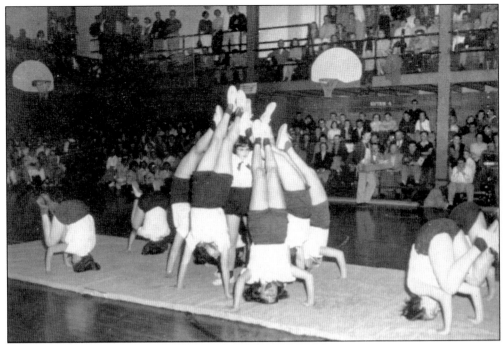

The Girls Athletic Association put on a halftime show during a basketball game in 1955. (Courtesy *Olympiad*.)

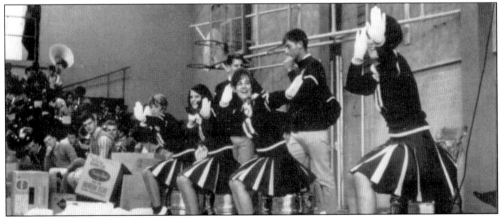

School spirit was linked with community pride. Here the 1967 pep staff performs a stand-up, sit-down routine using kegs from the largest private employer of the period, the Olympia Brewing Company. The brewery, located just blocks away, made an interesting neighbor; most students can recall how the sweet smell of barley and hops often wafted through campus. The gift shop at the end of the brewery tour was filled with "Oly" logo merchandise that could advertise both the beer and the school. The kegs, the Olympia Beer song that was played by the band at all home games, and most of the logo wear were removed from campus in the early 1990s amidst concern over their appropriateness. (Courtesy *Olympiad*.)

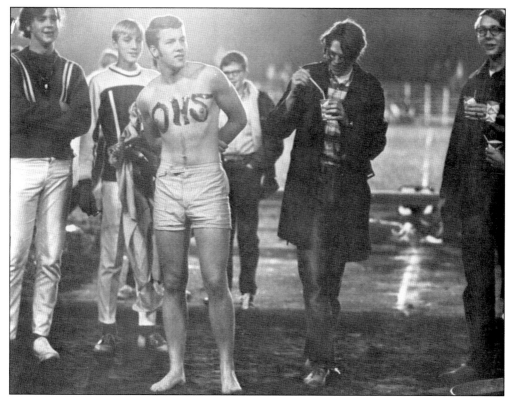

As ASB presidents go, some are very spirited while others use the position as a resume builder for college admissions. Here is 1969 president Tim White painting the Fort Vancouver High ASB president, who lost their good-spirited bet on the game when the Bears defeated them in the playoffs. (Courtesy *Olympiad*.)

Golf has long been played at OHS, first as a club sport and then as a team sport. Shown here in 1979 under the watchful eye of Coach Bob Ward, the team looks more like a casting call for *The Brady Bunch*. (Courtesy *Olympiad*.)

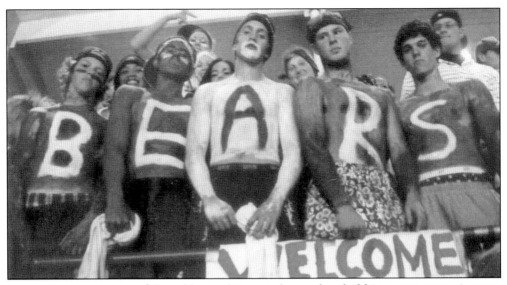

This image depicts one of the odder traditions to have taken hold in recent years. A group of highly spirited male students use their chests as a canvas to convey important messages to other fans at football games. The message of this group, photographed in 2003, is now recorded for posterity. (Courtesy *Olympiad*.)

Several traditions have lapsed over the years, and one of the most recent to fall out of favor was the homecoming or "big game" bonfire, at which a depiction of the other team's mascot or of a player, nicknamed "Johnny," met with a fiery end. Here we see "Johnny Aberdeen" just before he was torched in 1963. Imagine the scene behind Ingersoll Stadium: a big fire made from stacked wooden pallets; chanting cheerleaders; a jazzed-up football team; a quick pep talk from the coach. Then the opponent's mascot goes up in flames. Madness erupts as the fans go wild, and the excitement spills into the stands and onto the field. The tradition continued in the 1990s but has been on hiatus since then. (Courtesy *Olympiad*.)

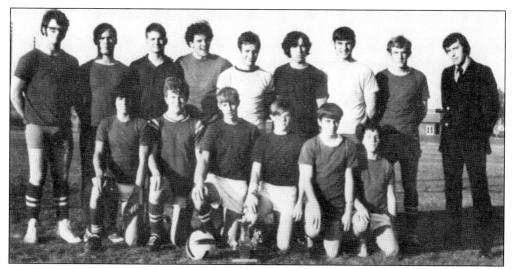

Soccer was a new sport when OHS introduced the program with this group of men, along with coach Mike Strong in 1971, though you wouldn't know it was their first season with such a great turnout.

It is unclear when the tradition of a run-through banner began, but this 1983 example of the handiwork of the pep staff is emblematic of the tradition. Imagine the thrill of being the first football player to crash through the 10-by-10-foot wall of paper after halftime and the head-spinning madness that it elicits from the crowd. (Courtesy *Olympiad*.)

LUMINARIES

PRINCIPALS

1901–05	W. W. Montgomery
1905–14	B. McClelland
1914–18	N. Jesse Aiken
1919–32	Leland P. Brown
1932–54	Willard J. Matters
1954–72	Don H. Bunt
1972–82	Leslie Metzger
1982–94	Dale Herron
1995–02	Dick Allen
2002–07	Matt Grant

ASB PRESIDENTS

1923–24	Smith Troy
1924–25	Robert Foster
1925–26	Oscar Adams
1926–27	William Gallagher
1927–28	Wallace Mills
1928–29	Walt Failor
1929–30	Adolph Schmidt
1930–31	Walter Davis
1931–32	Scotty McDonald
1932–33	Bert Horum
1933–34	Andrew Nelson
1934–35	Rodney Hansen
1935–36	George Maynard
1936–37	Glen Ashwill
1937–38	Douglas Johnson
1938–39	Roger Olson
1939–40	Jack Leary
1940–41	Jack O'Leary
1941–42	Bob Flem
1942–43	Cameron Kyle
1944–45	Wayne Hannah
1945–46	Leonard Malloy
1946–47	Willard Alverson
1947–48	Joe Bordeaux
1948–49	Doug McClary
1949–50	Sketer Ellis
1950–51	Phil Scutt
1951–52	Milton Gaines
1952–53	Bob Still
1953–54	Gerry Alexander
1954–55	Dave Wilson
1955–56	Richard Myatt
1956–57	Robert Richards
1957–58	John Rohrbeck
1958–59	Don Fiser
1959–60	Liv Wernecke
1960–61	Jerry Kay
1961–62	Mike Hannan
1962–63	Greg Tinker
1963–64	Forie Wilcox
1964–65	Ben Settle
1965–66	Jay Cushman
1966–67	Charles Saibel
1967–68	Greg Hart
1968–69	Tom Muirhead
1969–70	Tim White
1970–71	Bob Bergstrom
1977–78	Ken Ackerman
1978–79	Tom Reynolds
1979–80	Michael P. Hale
1980–81	Kim Meyer
1981–82	Patrick Bean
1982–83	Tony Giles
1983–84	Pat Harvey
1984–85	Doug Vaughn
1985–86	David Moody
1986–87	Tracy Overby
1987–88	Brian Barnes
1988–89	Rich Phillips
1989–90	Ryan Gerrits
1990–91	Bryce Mansfield
1991–92	Johann Deutscher
1992–93	Steve Ruthford
1993–94	Josh Gadbaw
1994–95	Claire Van Eenwyk
1995–96	Marc Lowe
1996–97	Matt Morrissey
1997–98	Daniel Heu-Weller
1999–00	Jenne Heu-Weller
2000–01	Daniel Mitchell
2001–02	Leanne Miller
2002–03	Phillip Heu-Weller
2003–04	Kenny Lee
2004–05	Amanda Garca
2005–06	Devin Currins
2006–07	Steve Kelson
2007–08	Austin Kelly

OUR MASCOT, THE BEAR

1972–73	Vicki Menghetti
1973–74	Pam Sajec
1976–77	Lori Talcott
1977–78	Lisa Davis
1978–79	Lisa Carstens
1979–80	Carolyn Lakewold
1980–81	Anne Butigan
1981–82	Denise Shipley
1982–83	Steve Manning
1983–84	Matt Misterek
1984–85	Steve Larsen
1985–86	Leif Olson
1986–87	Connie Phegley
1987–88	Tom Wright
1988–89	Pam Cooper
1989–90	Shannon Jackson
1990–91	Wanda Layton
1991–92	Catie Fairhead
1992–93	Charlie Lyman
1994–95	Manda Watson, Darbi Fankauser
1995–96	Jessi Herbert
1998–99	Else Jensen, Joey Herbert
1999–00	Lindsey Howitz, Kelli Wertanen
2000–01	Amy Flinton, Heather Hoffman, Sean Shiply
2001–02	Debbie Abbott, Natalie Veenhouer
2003–04	Katie Clark, Katie Merz
2005–06	Kelsi Cunniff, Polly Peterson
2006–07	Erica Clifford, Hope Murray

HOMECOMING QUEENS / KINGS

1949–50	Donna Voegelein
1950–51	Nancy Donahoe
1951–52	Donna Jensen
1952–53	Amy Jane Anderson
1953–54	Lenice Cooper
1954–55	Jo Sulenes
1955–56	Gloria Greenwood
1956–57	Marilyn Mahle
1957–58	Anna Galkowski
1958–59	Pat Osborne
1959–60	Marie Roy, Bill Tipton
1960–61	Sherry Seibold, Wink Dillaway
1961–62	Joyce McBride, Bob Andrew
1962–63	Elizabeth Wagner, Mike McCallum
1963–64	Vicki Marvel, Rod Hansen
1964–65	Betty VanderVeen, Dave Bailey
1965–66	Joan DeFord, Wolfgang Dammers
1966–67	Christy Monson, Paul Muirhead
1967–68	Judy Marvel, Mark Bean
1968–69	Betsy Haight, Kim Rotchford
1969–70	Teri Ramsauer, Eric Hansen
1971–72	Linda Campbell, John Smith
1972–73	Shawn Geary, Randy Trowbridge
1973–74	Doreen Maasjo, Dale Johnson
1974–75	Donna Shupp, Steve Nelson
1975–76	Gail Mesenbrink, Kevin Gallagher
1976–77	Camie Gearheart, Bob Strecker
1977–78	Sandra Riffero, Gary Nelson
1978–79	Helen Andersen, Mark Johnston
1979–80	Louri Fenton, Allen Taylor
1980–81	Kelly Plamondon, Dave Stocks
1981–82	Susan J. Kerr, Nels Mikkelson
1982–83	Lia Crabs, Ross West
1983–84	Sara Fenton, David Hougan
1984–85	Molly Freshley, Ben Scheffer
1985–86	Leah Plumer, Mason Denger
1986–87	Michele Cooper, Tim Connor
1987–88	Erica Howard, Chris Kerrick
1988–89	Margaret Vest, Keith Holder
1989–90	Kendra Carnes, Todd Gross
1990–91	Elen Wilcox, Bill Norberg
1991–92	Missy Loe, Jim Willard
1992–93	Jessie Coyle, Rhyan Smith
1993–94	Kym Gerst, Josh Gadbaw
1994–95	Darbi Fankauser, Justin Martin
1995–96	Jennie Gray, Patrick McDonald
1996–97	Sara Peters, Chris Bunson
1997–98	Amelia Rogerson, Travis Bond
1998–99	Hadley Jensen, Ben Rorem
1999–00	Megan Hewins, Zach Guydish
2000–01	Zoe Romero, Scott Knackstedt
2001–02	Kathleen Dahlen, Nick Dygert
2003–04	Katie Doolittle, Desmond Davis
2004–05	Janelle Andreasen, Jack Armstrong
2005–06	Rekha Ravindran, Devin Currins
2006–07	Many Ly, Josh Bury

OHS STATE CHAMPIONSHIPS

1929	Football, Basketball
1931	Boys Track
1935	Baseball
1936	Baseball
1952	Football
1956	Boys Swimming
1957	Boys Swimming
1963	Football
1978	Girls Cross Country
1980	Boys Tennis
1983	Boys Tennis, Football
1984	Boys Tennis
1985	Boys Swimming
1986	Boys Swimming, Basketball
1987	Girls Swimming
1996	Boys Golf, Girls Golf
1998	Boys Track, Girls Golf, Girls Volleyball
2006	Girls Track

OLYMPUS EDITORS

1901–02	Marion Blankenship
1905–06	Preston Uhler
1906–07	Cora Whiteman
1907–08	Katherine Hadley
1908–09	A.M. White, Lovina Wilson
1909–10	Clarence Butler, Gertrude Knox
1910–11	Blanche Billings
1911–12	Marguerite Coulter, Dena Whiteman
1912–13	Jesse Leverich
1913–14	Willis Blake, Don Heermans
1914–15	Donald Heermans
1915–16	Franklin Sumarlidason
1916–17	Katherine Johnson, Marguerite Coulter
1917–18	Dorsey Cunningham
1918–19	Nancy Wilson
1919–20	Frederick Johnson, Nancy Wilson
1920–21	Edward Anderson
1921–22	Stanley Knox
1922–23	Wilbur McGuire
1923–24	Anne Bayless Allen
1924–25	Haven Riesenweber, Stephen Christopher
1925–26	Stephen Christopher, Marie Askren, Van Hinkel
1926–27	Tam Gibbs, Gordon Parrott
1927–28	Eileen Whittall, Mary Exline
1928–29	Mary Lasher
1929–30	Adolph Schmidt, Katherine Ward, John Lucas
1930–31	Lois Griggs, Celia Marion
1931–32	Ramona Rockway
1933–34	Winnefred Castle
1934–35	Ralph Swanson
1935–36	Ralph Swanson
1936–37	Charlotte Stevens
1937–38	Ronald Bostwick
1938–39	Eldon Barrett, James Morris
1939–40	Lorraine Erickson
1940–41	Bill Russell,
1943–44	Casper Michaelson, Dan West
1944–45	Evelyn Bean
1945–46	Don Lehman
1946–47	Gust Angelos
1947–48	Jeanne Henson, Ida Jenkins
1948–49	Jay Grant, Marilyn Ruchty

Year	Name(s)
1949–50	Carol Fleming
1950–51	Joyce Hershey, Donna Jensen
1951–52	Marge Simpson, Joan Walsh
1952–53	Norma Muir, Charles Thompson
1953–54	Jane Walsh, Roberta Caldwell
1954–55	Gail Motteler, Sharon Cole
1955–56	Earnst Carsentsen
1956–57	Marilyn Mahle, Dorene Osborne
1957–58	Betsy Top, Dave Cammarano
1958–59	Hallie Niemi, Dick Hooper
1959–60	Lila Davis
1961–62	Anne Thomson, Laura Watson
1962–63	Barbi Barlow
1963–64	Jane Thorndale, Lynn Rosellini
1964–65	Jane Thorndale
1965–66	Linda Steere, Pat Dobler
1966–67	Nancy Jessesemy, Sue McCroskey
1967–68	Terri Timm
1968–69	Carol Anderson
1971–72	Merrilee Donnell
1972–73	Dan Wheat
1973–74	Sam Barr
1974–75	Thomas J. Sam Barr
1975–76	Dan Fisher, Mark Tracy, Sandy Loyer
1976–77	Sandy Loyer
1977–78	Scott Tanner, Scott Wilson
1979–80	Bryan Frost, Kathy Young
1980–81	Barbara Bunce, Heather Doran
1982–83	Becky Lundberg
1983–84	Kami Beahm, Holli Shook
1985–86	Doug Neufeld Francie Froelich
1986–87	Connie Phegley
1987–88	Allison Brennan
1989–90	Tiffany Allen Thuy Nuygen
1994–95	Heather Kazada
1996–97	Kim Bush
1997–98	Jocelyn Finch
1998–99	Allison Dozier
1999–00	Carly Crouch, Taunya Woo
2000–01	Amelia Showalter
2002–03	Brooke Fennerty, Mallory Wilson
2004–05	Brennan Thome
2005–06	Aaron Bray, Devin Currins
2006–07	Rachel Reclam
2007–08	Kent Wu

MAY QUEENS / KINGS

Year	Name(s)
1916–17	Ida Stomner
1918–19	Anna Springer
1922–23	Louise Martin
1923–24	Catherine Redpath
1924–25	Dolores Shugarts
1925–26	Laura Whitwick, Jack Whittall
1927–28	Margery Williams, Irving Hart
1928–29	Irene Sadler, Charles Potter
1929–30	Dorothy Cook, William Priestly
1930–31	Marianne Flanders, Russell Nieson
1931–32	Rheba Schmidt, Herschel "Chick" Hardisty
1933–34	Barbara Fairchild, James Carpenter
1934–35	Gertrude Cowgill, Don Burrell
1935–36	Gloria Pierce, Glenn Peterson
1936–37	Virginia Powell, Arnold Hardman
1937–38	Shirley Annis, William Brenner
1938–39	Jeane Lindberg, Richard "Dick" Dodge
1939–40	Bud Lews, Jean Bridges
1940–41	Virginia Twohy, Jack O'Leary
1941–42	Virginia Powell, Arnold Hardman
1942–43	Normajeanne Zintheo, Ward Rockey
1943–44	Jean Bridges, Bud Lewis
1944–45	Shirley Gruver, Cameron Kyle
1945–46	Norma Jean Simila, Leonard Malloy
1946–47	Marilyn Smart, Willard Alverson
1947–48	June Bowen, Joe Bordeaux
1948–49	Mary-Jane Shivas, Doug McClary
1949–50	Royal Mower, Mac Partlow
1950–51	Nancy Donahoe, Phil Scutt
1951–52	Betty Lee Harrison, Milton Gaines
1952–53	Amy Anderson, Bob Still
1953–54	Kathy Kanouse, Michael Hunt
1954–55	Nancy Daly, David Wilson
1955–56	Carol A. Berntsen, Richard Myatt
1956–57	Beth Ellen Patterson, Bob Richards
1957–58	Kathy Aetzel, Richard Springer
1958–59	Jan Pantier, Don Fiser
1959–60	Toni DeBiose, Bill Tipton
1960–61	Merry Galkowski, Ken Fiser
1961–62	Linda Hopkins, Bob Andrew
1962–63	Pam Weiks, Wayne Olsen
1963–64	Sallie Howe, Larry Leonardson
1964–65	Mary Jane Cowan, Dave Bailey
1965–66	Joan DeFord, Jim Lockhart
1966–67	Sandi Barber, Pete Olbertz
1967–68	Vicki Markhoff, Roj LeClerc
1968–69	Peggy Murray, Dave Bean
1972–73	Linda "Kay" Loftis, Patrick Crow
1973–74	Carla Bahler, Ben Emmons
1974–75	Candy Andrews, Steve Vipond
1975–76	Bambi Litchman, Kevin Gallagher
1977–78	Dyne Haynes, Claude Morgan
1981–82	Tami LaFreniere
1985–86	Emily Johnson, John Cook
1986–87	Shelly Cooper
1990–91	Adriann Fredrick, Andy Boe
1992–93	Tera Peterson, David McNicol
1997–98	Ameilia Rogerson, Travis Bond
2006–07	Jill Goodell, Kent Stormans

SONG QUEEN / YELL KING

Year	Name(s)
1909–10	Dixon Shivley
1915–16	Herndon Dalton
1916–17	Leonard Levy
1917–18	J. Truman "Trolly" Trullinger
1918–19	Earnest Barnes
1920–21	William Strock
1922–23	Inez Sawyer, Wilson Tyler
1923–24	Harold Meyer
1924–25	Lewis Nommensen
1925–26	Lois Henderson, Wesley Leach
1926–27	Frank Sharp
1927–28	Keith MacDonald
1928–29	Dan McCaughan
1929–30	Edgar McDonald
1930–31	Lawrence Enbody
1933–34	Wanda Sousie, Alice Schmidt, Roy Hurl, Bill Phillips
1934–35	Thomas Ratliff
1935–36	Edward Andrews, Harold McCarty
1936–37	Bill Phillips
1937–38	Shirley Annis, Jack Hudson
1938–39	Jeane Lindberg, Everett Skinner
1939–40	Billie Sousie, Harry Simmons
1944–45	Delight Hunt, Bob Dawley
1945–46	Virgine Wade, Larry Grant
1946–47	Marilyn Smart, Don Hill
1947–48	Jane Simmons, Les Willett
1948–49	Virginia Meyer, "Boxie" Crewdon
1949–50	Royal Mower, Tom Harding
1950–51	Marilyn Melin, Lawrence Dennis
1951–52	Betty Harrison, Jack Nunez
1952–53	Marilyn Melin, Tom Bloom
1953–54	Kathy Kanouse, Robert Dean
1954–55	Nancy Daly, Lee O. Kueckelhan
1955–56	Carol Berntsen, Bob Richards
1956–57	Dorothy Bergh, George Sjodin
1957–58	Kathy Aetzel, Mel Woods
1958–59	Jan Pantier, Denny Nelson
1959–60	Sheri Zabel, Jim Malysz
1960–61	LaLanne Bantz, Skip Knox
1961–62	None Named, Kit Marcinko
1962–63	Patti Clintworth, Jim Fitzgerald
1963–64	Karin Hill, Bob Summers
1964–65	Mary Jane Cowan, Dave Ohman
1965–66	Sue Mickey, Mick Phillips
1966–67	DeAnne Barre, Greg Waddle
1967–68	Kathy Tuohey, Steve Lemons
1968–69	Pam Robinson, Dan Roberts
1969–70	Cyndy McBride, Jay Mills
1970–71	Scott Robbins
1971–72	Janice Deboer, Steve Shamberg
1972–73	Sarah Weaver

HOMECOMING STRIPPERS

	
1969–70	Kit Blue
1971–72	Tom Hays
1972–73	Skip Houser
1974–75	Rex Schade
1975–76	Kevin Weiks
1977–78	Rod Ritter
1979–80	Wade Wilkins
1980–81	Mike Parsons
1981–82	Eric Strand
1982–83	Dennis Shea
1983–84	Pete Smith
1984–85	Mike Cairone
1985–86	Scott Lohr
1986–87	Mark Elias

DRUM MAJORS

	
1933–34	Bob Ranney
1935–36	Charles Fitschen
1936–37	Charles Fitschen
1937–38	Art Holbrook
1938–39	Vernon Briggs
1942–43	Vernon Briggs
1944–45	Ivan Briggs
1945–46	Doh Lehman
1946–47	Don Lehman
1947–48	Don Lehman
1948–49	Patty McNamara
1949–50	Patty McNamara
1950–51	Del Shaw
1951–52	Bob Still
1952–53	Bob Still
1953–54	Don Philpott
1954–55	Don Philpott
1955–56	Roger M Laing
1956–57	Gerald Schmidke
1957–58	Jeff Lane
1959–60	Larry Schmidke
1960–61	Larry Schmidke
1965–66	David Goedecke
1966–67	Tom Ajax
1967–68	Dan Ketchum
1968–69	Brian Cole
1969–70	Cris Andersen
1970–71	Scott Mather
1971–72	Erik Hanson
1972–73	Stephen Way
1973–74	Verle Ketchum
1974–75	Mike Simpson
1975–76	Paul Visminas
1977–78	Kathy Taylor
1979–80	John Hitchman
1980–81	Jim Blundell
1981–82	Catherine Ernst, Todd Weir
1983–84	John Stocks
1984–85	Dave Pedigo
1985–86	Steve Bassett
1986–87	Jenny Blecha
1990–91	Matt Winberry
1994–95	Daryl Ducharme
2003–04	Brian Rascon
2004–05	Brennan Thome
2005–06	Sean Currens
2006–07	Sean Currens

DISCOVER THOUSANDS OF LOCAL HISTORY BOOKS FEATURING MILLIONS OF VINTAGE IMAGES

Arcadia Publishing, the leading local history publisher in the United States, is committed to making history accessible and meaningful through publishing books that celebrate and preserve the heritage of America's people and places.

Find more books like this at
www.arcadiapublishing.com

Search for your hometown history, your old stomping grounds, and even your favorite sports team.

Consistent with our mission to preserve history on a local level, this book was printed in South Carolina on American-made paper and manufactured entirely in the United States. Products carrying the accredited Forest Stewardship Council (FSC) label are printed on 100 percent FSC-certified paper.